You Can Draw
Cartoons

Lou Darvas

DOVER PUBLICATIONS, INC.
Mineola, New York

ACKNOWLEDGMENT

To Hal Talburt, for his sole contribution on the art of the editorial cartoon...To George Wolfe, gag cartoonist, who gave us the "inside" on the slick gag market...To Neg Cochran, who has so ably taken over the chores of the late J. R. Williams; to Leslie Turner, Galbraith, Frank O'Neal, Nadine Seltzer, and Kate Osann for contributing their features which appear daily in hundreds of newspapers throughout the country...To East Lynn, Comics Editor of the Newspaper Enterprise Association (NEA), who compiled these features for us...To Mr. Frank Dittrich, publisher of All-Pets Magazine, for allowing us to reprint the mongrel that heads off the lesson on "Animals."

Bibliographical Note

This Dover edition, first published in 2003, is a slightly emended republication of the work originally published by Doubleday & Company, Inc., Garden City, New York, in 1960. The final two pages of the original, which listed magazine and newspaper markets available to cartoonists, are too outdated to be useful and have been dropped from this edition.

Library of Congress Cataloging-in-Publication Data

Darvas, Lou.
 You can draw cartoons / Lou Darvas.—Dover ed.
 p. cm.
 Slightly amended republication. Originally published: Garden City, N.Y. : Doubleday, 1960.
 ISBN 0-486-42604-1 (pbk.)
 1. Cartooning—Technique. I. Title.
NC1320 .D35 2003
741.5—dc21

2002035177

Manufactured in the United States of America
Dover Publications, Inc., 31 East 2nd Street, Mineola, N.Y. 11501

 # CONTENTS

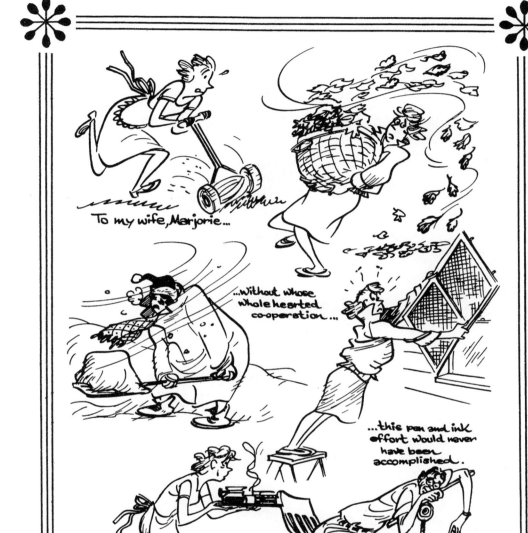

INTRODUCTION

Cartooning, one of the youngest forms of art, has perhaps the greatest number of outlets for opportunities such as:

Magazines — TV — Greeting Cards —
Car Cards — Advertising Agencies —
Posters — Illustrations — Books —
Newspapers — Newspaper Syndicates —
Department Stores — Direct Mail —
and Many Others.

We have designed this book to teach you the fundamentals of this fun profession in the simplest manner possible... omitting long essays on otherwise dull theories.

We want you to be an "eye witness" to every page... we want you to carefully study, copy, memorize, then re-draw what you have memorized... this same system once taught you your A-B-C's ...it now can teach you the art of cartooning.

As you continue to work this way, your own style will take over just as your own handwriting style evolved.

Educational authorities have agreed that you can learn many times more rapidly from pictures than from the printed word. Pictures make a lasting impression on your mind... words, on the other hand, set up in cold type, are easily forgotten!

As you leaf through the pages of this book remember — YOUR SINCERE DESIRE WILL BE THE GUIDING FACTOR IN YOUR BECOMING A SUCCESSFUL CARTOONIST!

Though we may not be able to transport you directly to your port of success, the experience you will attain en route, will be most rewarding... bon voyage!

LOU DARVAS

1

Your Materials

PENS: ALL YOUR MATERIALS CAN BE PURCHASED FROM AN ART SUPPLY STORE... OR SOME STATIONERY STORES... THESE PENS ARE USED THROUGHOUT THIS BOOK ... ① HUNT NO. 513 ② HUNT NO. 512 ③ ESTERBROOK NO. 358.

PENCILS: YOUR BEST BET IS TO STAY WITH AN "H" PENCIL – ALL ART PENCIL MAKERS HAVE ONE... WE ARE USING A "VENUS" MAKE.... NO. 2 and NO. 3 ARE CRAYON PENCILS.... A KOH-I-NOOR FLEXICOLOR No. 60 and PRISMACOLOR NO. 935

INK: "HIGGINS" INK WOULD BE OUR CHOICE ...(SMALL BOTTLE) – MAKE YOUR OWN STAND OUT OF LIGHT CARDBOARD ↗

PLACE BOTTLE HERE DRAW A LINE AROUND – CUT ON DOTTED LINES

BEND BACK and INSERT BOTTLE

BRUSHES: TWO BRUSHES WILL CARRY YOU FOR AWHILE... THEY SHOULD BE GOOD ONES – TRY WINSOR & NEWTON'S – NO.'s 2 and 4 SERIES 7.

MISCELLANEOUS: YOU'LL NEED A BOX OF THUMBTACKS... AND A GOOD ALL-AROUND ERASER.... WE SUGGEST EBERHARD-FABER'S RUBKLEEN.

YOUR DRAWING BOARD SHOULD BE MADE OF SOFT-WOOD – SET IT ON YOUR LAP AND LEAN IT AGAINST A TABLE OR DESK.

YOUR PAPER ? BRISTOL BOARD PLATE OR VELLUM FINISH – TRY BOTH!

Loosening Up

GRAB YOUR PENCIL AND DOODLE AWAY... COPY THESE SIMPLE EXERCISES AND GET THE FEEL OF PENCIL FREEDOM...

REMEMBER!! EVERY SKETCH YOU COPY FROM THIS BOOK MUST BE DRAWN IN PENCIL **FIRST!**

NOTICE THE FIGURE EIGHT USED TO MAKE THE BRIM OF HAT

SO LIMBER UP — —THERE ARE A FEW MORE PAGES LIKE THIS

Loosening Up

SEE HOW THESE CRAZY LINES...

...TRANSFORM THEMSELVES...

... INTO PEOPLE..

"..and" THINGS

FOOL AROUND WITH CRAZY LINES —LET YOURSELF GO, MAN... IN PENCIL ONLY!!

Pen & Brush Handling

THE PEN AND BRUSH ARE YOUR TOOLS OF THE TRADE...LEARN TO USE THEM WITH EASE AND FEELING— —TRY NOT TO RUSH YOUR PEN WORK— SPEED WILL COME LATER.

YOU WON'T GO WRONG BY USING AN EVEN THICKNESS OF LINE AROUND THE OUTLINE OF A COMIC FIGURE

CONNECT ALL INK LINES ON YOUR FIGURE

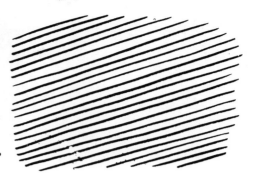

SHADING LINES
KEEP LINES EVENLY SPACED.

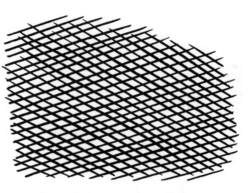

CROSS-HATCHING for SHADING
or PATTERNS
ALLOW ONE SET OF LINES TO DRY BEFORE APPLYING ANOTHER— KEEP SECOND SET SAME SPACE APART.

SPREAD LINES
START BY HOLDING PEN LIGHTLY—THEN BEARING DOWN TO GET THICK EFFECT— THEN LETTING UP ON PRESSURE.

INK IN THE HEAD EVENLY.. ...USE FINER LINES TO FINISH OFF THE FACE AROUND NOSE, HAIR, CHEEK and FILLING IN MOUSTACHE

5

Pen & Brush Handling

LIGHT

MEDIUM

DARK

STRAIGHT SHADING

FOUR-WAY CROSS-HATCHING

SOLID BRUSH

SIMPLE LINE WORK

ABOVE: SOME PEN TREATMENTS FOR PANEL CORNERS

BELOW: ALL BRUSH WORK WITH THE EXCEPTION OF PEN-SHADING IN FACE OF INDIAN

BANG

NOTE "DRY BRUSH" WORK ON HAIR

Pen & Brush Handling

THE TRUNK HERE BLENDS IN WITH THE GRASS — NOTE HOW THOSE CRAZY LINES COME INTO PLAY

TREES SEEM BAFFLING — BUT DON'T LET 'EM THROW YOU — GET YOUR OUTLINE DOWN AND YOUR SHADING LINES OPEN — CROSS-HATCHING HERE and THERE

WITH PEN and BRUSH

DIP BRUSH INTO INK — DRAG ON SEPARATE PAPER...

...TO GET DRY BRUSH EFFECT USED BELOW — FLATTEN ENDS UNTIL SINGLE HAIRS SPREAD OUT — THEN USE.

A STUDY IN CONTRAST — NOTICE HOW THE FIGURE, DONE ENTIRELY WITH A BRUSH, CREATES THE ATTENTION

7

Patterns & Coloring

"COLORING" A DRAWING MEANS SIMPLY THIS — WHEN YOUR COMIC IS COMPLETED IN ITS OUTLINE FORM AND THE BACKGROUND IS PRETTY WELL SET — "FILLING IN" OR "SPOTTING" OF BLACKS AND MIDDLETONES ARE NECESSARY TO FINISH UP YOUR PRODUCT...

...CARE MUST BE TAKEN THOUGH SO AS NOT TO OVERLOAD THE SCENE.

↑ THIS STREET SCENE ABOVE IS OBVIOUSLY INCOMPLETE...

...AND ALTHOUGH SOME CARTOONS GO THROUGH THIS WAY AS A FINISHED PRODUCT, WE FEEL A BIT MORE SHOULD BE ADDED

← HENCE, OUR END RESULT... WITH JUST A FEW TOUCHES OF SOLID BLACK, A BIT OF SHADING HERE AND THERE, THEN A LITTLE MORE BACK-GROUND, GIVES US A CARTOON WITH A TOUCH MORE OF LIFE.

Patterns & Coloring

BEWARE OF
PATTERNS
AGAINST
PATTERNS
AS IN THE
CASE OF THE
CAMOUFLAGED
SNAKE.

Patterns & Coloring

A SINGLE LINE PATTERN HANDLED STRAIGHT UP AND DOWN

...AND WITH THE CONTOUR OF THE SUIT

10

The Comic Head

Comic heads can be as simple or as complicated as you wish to make them...The main purpose of this lesson is to learn the proper construction of the head in all of its positions.....once you have mastered this, additional treatment may be rendered....
REMEMBER !! take your time!! Speed will come later.
We will work with three basic methods —
the **BOX...OVAL** or **CIRCLE**...and the **ODD** shape
Study these very carefully—and COPY each head as you go along... if you follow through on this—by the time you finish—you should be able to draw a comic head on your own.

BOX METHOD

EYE LINE

OVAL or CIRCLE

EYE LINE

ODD SHAPE

EYE LINE

The Comic Head

THE BOX METHOD

FIRST DRAW A SQUARE—
— DIVIDE IT INTO
FOUR PARTS...

EYE LINE

...PLACE THE EYE
ON "EYE LINE"—
—ADD BROW...

— NEXT ADD EAR —
NOSE AND TOP OF
HEAD...

...NOW THE CHIN LINE
AND SUGGESTION OF HAIR...

INK IN
THIS
STEP ➤

...COMPLETE CHIN LINE—
ADD LINE AROUND EYE...

...SHADE IN HAIR—ADD
CHEEK LINE—LET INK
DRY—AND ERASE.

HERE ARE A FEW SUGGESTIONS FOR EYES-NOSES-HAIR and CHINS
— TRY YOUR HAND AT DRAWING A FEW HEADS USING THIS SYSTEM...
...ADDING FROM THE DIFFERENT FIXTURES SHOWN BELOW.

EYES: **NOSES:**

TOPS of HEADS and HAIR

CHINS:

The Comic Head

ANOTHER HEAD TO WORK ON... THIS OVAL METHOD IS THE MOST POPULAR OF THE THREE...

THE **OVAL** METHOD

FOUR PARTS...

EYEBROWS...

AND TOP OF DOME...

...ADD MOUTH-SUNKEN CHEEKS — THE SHADE HAIR...

INK IN THIS STEP ↓

...FINISH OFF WITH FACE SHADING and SHADOWS.

NOW TRY DRAWING YOUR OWN COMIC HEAD USING A MIXTURE OF THE FEATURES SHOWN HERE.

EYES:

HEAD TOPS and HAIR

NOSES:

CHINS:

13

The Comic Head

ODD SHAPE

DIVIDE INTO FOUR PARTS......... EYES AND EYEBROWS NEXT... ...ADD NOSE—EARS AND TOP CONTOUR OF HEAD

INK IN THIS STEP

...NOW FOR THE MOUTH—CHIN AND HAIR LINE

...ADD SUNKEN CHEEKS —EYE LINES—MORE HAIR

COMPLETE BY ADDING MOUSTACHE— SHADING HAIR and FACE.

PUT TOGETHER YOUR OWN ODD SHAPE, USING THE FIXTURES SHOWN BELOW.

TOPS of HEADS and HAIR

EYES

NOSES

CHINS

The Comic Head

NOTE THE POSITION OF THE EYE-LINE IS SLIGHTLY ABOVE CENTER

...THE EYE-LINE IS BACK ON CENTER IN BOTH CASES...

EYE-LINE IS SLIGHTLY ABOVE CENTER AGAIN

THE EYE-LINE IS ABOVE CENTER HERE... ...AND SLIGHTLY LOWERED HERE

15

The Comic Head

IN $3/4$ TIME

THE THREE-QUARTER HEAD WILL GIVE YOUR WORK THE TOUCH OF A "PRO"...MAKE GOOD USE OF THE GUIDE LINES...CHECK and COPY THESE HEADS SEVERAL TIMES...

The Comic Head

COPY THESE POSITIONS, THEN RE-COPY THE ONES THAT GIVE YOU THE MOST TROUBLE.

A SQUINT AT SOME SPECS —

17

The Comic Head

NOTICE HOW <u>LOW</u> THE EARS ARE PLACED WHEN HEAD LOOKS **UP**...

...AND HOW <u>HIGH</u> WHEN HEAD LOOKS **DOWN** —————— CHECK THE EYE-LINE FOR THE REASON

THE BOX METHOD WILL HELP WHEN DRAWING A REAR VIEW

The Comic Head

PLACING THE HAT ON THE HEAD PROPERLY IS IMPORTANT... CHECK THESE SIMPLE STEPS FOR THE ANSWER

BRIM LINE

OVAL BRIM

SAUCER-TYPE BRIM

FIRST DRAW A BRIM-LINE WHERE THE HAT SHOULD REST... DRAW IN THE BRIM.AND THEN THE CROWN

THIS BRIM IS JUST A LONG OVAL THAT CAN BE SNAPPED IN FRONT

LONG OVAL BRIM AGAIN HERE FOR THE HOMBURG...

THE "FIGURE EIGHT" MAKES A GOOD DERBY AND TOPPER IN A 3/4 VIEW

...and THIS BACK VIEW

COPY THESE COVERED HEADS AND ONCE YOU GET THE "BRIM-LINE" IDEA DOWN PAT- YOU'RE IN BUSINESS !!

The Comic Head

COPY THESE HEADS –
THEN TRY ORIGINATING YOUR
OWN CAST OF CHARACTERS
WITH THE SAME HEADGEAR

The Comic Head

SOME SIMPLE and SIMPLIFIED FACES

NOTICE THE ABSENCE OF FACE-SHADING HERE—YOU MAY PREFER THIS TYPE

The Comic Head

Expression

TO ANIMATE THE FACE, TRY TO "FEEL" OUT THE EXPRESSION...LOOK MAD AND YOU'LL DRAW MAD. PICTURED HERE ARE BASIC PRINCIPLES YOU SHOULD KNOW ABOUT THE EYEBROWS, EYES, MOUTH, AND HAIR... STUDY THEM, THEN PROCEED INTO THE FOLLOW- ING PAGES FOR A VARIETY OF OTHERS. COPY THEM AS YOU GO ALONG.

IT'S NOTHING..

...IT'S SOMETHING

MAD...

...GLAD

FEAR

SNEER

TEAR

THROW YOUR- SELF INTO YOUR CARTOONS-- --GUESS WHAT EXPRESSIONS ARE BEING DRAWN IN EACH CASE

Expression

EVERYTHING FROM HATE TO LOVE IS PICTURED BELOW—STUDY AND COPY THESE MOODS UNTIL YOU HAVE THEM DOWN PAT.

Expression

HERE ARE A FEW SLIGHTLY
EXAGGERATED EXPRESSIONS...
...DRAWN ENTIRELY WITH A BRUSH—
—TRY IT FOR THAT LOOSE EFFECT

EVERYTHING
DROOPS FOR
THE DOWN-IN-
THE MOUTHER

The Hand

IS ONE OF THE HARDEST PARTS OF THE BODY TO DRAW...BUT THE COMIC HAND CAN BE FAIRLY SIMPLE — STUDY AND COPY THESE HANDS...
...DON'T FORGET YOU HAVE A GOOD MODEL IN YOUR OTHER HAND...
...USE IT OFTEN

The Hand

OPEN PALM:

THE POINT:

HAND OUT:

TIGHT FIST:

PALM OR BACK OF HAND

FINGERS

THE BACK OF THE HAND IS THE SAME AS THE PALM...WITHOUT THE CREASE MARKS

The Hand

COPY THESE HANDS —
IT MAY BORE YOU, BUT
KEEP GOING... IT'LL
PAY OFF IN THE PALM.

28

The Hand

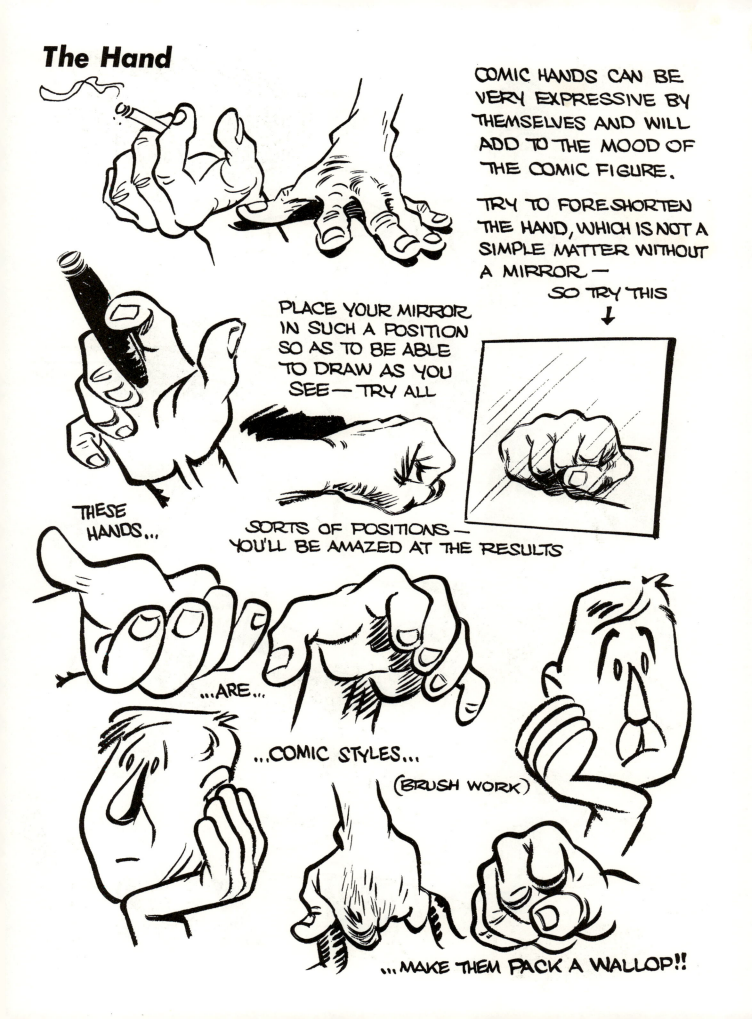

COMIC HANDS CAN BE VERY EXPRESSIVE BY THEMSELVES AND WILL ADD TO THE MOOD OF THE COMIC FIGURE.

TRY TO FORESHORTEN THE HAND, WHICH IS NOT A SIMPLE MATTER WITHOUT A MIRROR —

SO TRY THIS ↓

PLACE YOUR MIRROR IN SUCH A POSITION SO AS TO BE ABLE TO DRAW AS YOU SEE — TRY ALL

THESE HANDS...

SORTS OF POSITIONS — YOU'LL BE AMAZED AT THE RESULTS

...ARE...

...COMIC STYLES...

(BRUSH WORK)

...MAKE THEM PACK A WALLOP!!

The Hand

Feet & Shoes

FIRST THE BABY SHOES and BABY FEET.

...THEN THE BARE-FOOT BOY...

...WITH SHOES ON...

..NEXT, THE HIGH SCHOOL LAD...

...ON HIS FIRST DATE...

DRAWING COMIC FEET AND SHOES REQUIRES NOTHING MORE THAN A GOOD LOOK AT YOUR OWN FEET AND SHOES...
STUDY THEM—COMPARE THEM WITH THE DRAWINGS IN THIS LESSON—LOOK FOR THE LIKENESS FROM A COMIC POINT OF VIEW...

ALTHOUGH IT WOULD HELP—THERE IS NO NEED TO KNOW THE ANATOMY OF A FOOT—JUST COPY YOUR OWN—AND MAKE IT A COMIC !!

...THEN WEDDING BELLS...

...WORK SHOES

...AND, AS THE YEARS GO BY, — OLD TIRED FEET

Feet & Shoes

SOME FEET
THAT "BARE" LOOKING INTO

Feet & Shoes

A TOUCH OF REALITY CAN BE OBTAINED BY CORRECTLY DRAWING THE INSTEP OF A MAN'S SHOE.

RIGHT LEFT

EYE-LEVEL VIEW

BACK VIEW... FEET IN... ...FEET OUT

MOST POPULAR VIEW
IS DRAWN FROM THIS
TOP ANGLE

BACK
VIEW

FRONT
VIEW

TRY TO GET THE FEELING THAT
BOTH FEET ARE PLANTED
SOLIDLY ON THE GROUND

33

Feet & Shoes

A SIMPLE WAY TO DRAW A COMIC SHOE:

1.

2.

3.

NOTE SHADOW

Feet & Shoes

Feet & Shoes

WILLIE OFF THE PICKLE BOAT

RANGE RIDER

ROD RIDER

Ⓐ ZOOT-SUITER

Ⓑ LAW MAN

Ⓒ PECK'S BOY

Ⓓ SUMMER TIME

Ⓔ SOLID COMFORT

A-B-C-D-E DRAWN WITH NO.4 BRUSH

36

The Simple Comic Figure

IN THIS LESSON WE WILL SHOW YOU HOW TO CONSTRUCT THE COMIC FIGURE IN ITS MOST SIMPLE FORM, DISREGARDING DETAILS OF CLOTHING, PATTERNS, SHOES, WRINKLES, ETC.

THE AVERAGE FIGURE IS USUALLY DRAWN **8** HEADS HIGH— BUT IN CARTOONING, ONE DOES NOT HAVE TO ADHERE TO THIS ARTISTIC LAW—

FOR INSTANCE—

HERE IS JOE, ONLY **4½** HEADS HIGH...

and RUDY IS ONLY **3½** HEADS HIGH...

and HERE IS MALCOLM, **4** HEADS HIGH — WE POINT THIS OUT MERELY TO SHOW HOW CARTOONING CAN BE AN EXAGGERATED FORM OF REALISM AND STILL BE A SALABLE ITEM.

37

The Simple Comic Figure

WE'LL GET YOU STARTED ON THE SIMPLE TYPE COMIC, THEN THE MORE COMPLETE FIGURE WILL COME EASIER

SOME SAY THE COMPLETE STICK METHOD WORKS BEST...

...WE LIKE THE COMBINATION OVAL (FOR TUMMY and HEAD) and STICK (LEG and ARM)

THIS METHOD GIVES YOU A QUICK LOOK AT THE TYPE OF FIGURE YOU WANT...

...LIKE FAT ———— THIN ———— HUSKY and STUMPY

The Simple Comic Figure

SOME MORE COMBO METHODS
AND THEIR FINISHED PRODUCTS—
COPY THESE and THOSE ON
THE OPPOSITE PAGETHEN
TRY SOME OF YOUR OWN
REMEMBER – KEEP 'EM SIMPLE

The Simple Comic Figure

ONCE AGAIN—WE ARE PAYING NO ATTENTION TO THE DETAILS IN CLOTHING—THIS LESSON WAS MEANT TO ACQUAINT YOU WITH THE **FORM** OF A COMIC FIGURE

COPY THESE FIGURES, STARTING WITH THE SMALL COMBO SKETCH, THEN WORK IT UP FOR INKING

Clothes & Wrinkles

THERE ARE TWO WAYS
TO HANDLE WRINKLES
IN CLOTHES — THE OVER-
DONE AND SIMPLE STYLE.
IN THIS FIGURE OF
AN OLD MAN, THE OVER-
DONE STYLE IS USED —

— AS YOU CAN SEE, IT
IS MOST EFFECTIVE...

But...

...THE SAME FIGURE
CAN BE JUST AS
EFFECTIVE WITH THE
SIMPLIFIED TYPE OF
WRINKLE, AS SHOW
AT THE RIGHT →

WE WILL TRY TO
ENCOURAGE YOU TO
USE THIS SIMPLIFIED
METHOD AS THE MORE
DETAILED STYLE WILL
COME TO YOU LATER

41

Clothes & Wrinkles

WRINKLES CAN BE MADE VERY SIMPLE and STILL BE EFFECTIVE.

STUDY THE WRINKLES THAT ARE MARKED WITH ARROWS – THEY ARE THE MOST COMMON TYPE

BENT ARM

ARM AT SIDE – SLIGHTLY FORWARD

STANDING

HALF KNEE BEND

FULL KNEE BEND OR SITTING

Clothes & Wrinkles

FIGURE COVERED WITH A SHEET

SIMPLE WRINKLES SHOWN BY ARROWS

SAME STANCE WITH LESS WRINKLES HERE

PRACTICALLY NO WRINKLES

WALKING

THROWING

THESE SIMPLIFIED FIGURES SHOW HOW MUCH ACTION YOU CAN GET WITH JUST A FEW LINES AND PRACTICALLY NO WRINKLES

Clothes & Wrinkles

THIS FIGURE SHOWS HOW YOU CAN GET A WRINKLED EFFECT BY MERELY FILLING IN THE COAT WITH A BRUSH

NOTICE HOW CLOTHES REACT TO A PULL OF AN ARM

SHADOWS UNDER COATS and LAPELS ARE EFFECTIVE

NOTICE WRINKLES IN ROLLED UP SLEEVE (ARROW)

THE QUIET OF A STANDING MAN — PRACTICALLY NO WRINKLES

Clothes & Wrinkles

FRONT VIEW:

SOME SIMPLE BASIC WRINKLES
FOR THE WALKING MAN

BACK VIEW

SIDE VIEW:

THREE-QUARTERS VIEW

The Complete Figure

A WALKING FIGURE WILL MOVE HIS RIGHT ARM FORWARD AS HIS RIGHT LEG MOVES BACKWARD... LEFT ARM FORWARD AS LEFT LEG MOVES BACKWARD

A GOOD METHOD FOR DRAWING A THREE-QUARTER VIEW OF A MAN WALKING IS TO STRAIGHTEN THE FORWARD LEG ALONG WITH THE OPPOSITE LEG — THE ARMS WILL STILL POSITION THEMSELVES AS EXPLAINED ABOVE

The Complete Figure

THE SAME PRINCIPLE APPLYS HERE AS WITH THE WALKING FIGURE

A MAN THROWING WITH HIS <u>RIGHT ARM</u>, EXTENDS HIS <u>LEFT LEG</u> AND VICE VERSA WITH LEFT ARM THROWING

A JUMPING FIGURE USUALLY THROWS BACK HIS ARMS WHILE IN FLIGHT

COPY THESE POSITIONS SEVERAL TIMES—ACQUAINT YOURSELF WITH THESE MOVING FIGURES

47

The Complete Figure

A FEW MORE SKETCHES SHOWING HOW THE FIGURE BENDS, STRETCHES, DIGS, REACHES AND DIVES — — DRAW THESE A FEW TIMES—YOU'LL LEARN TO DRAW THEM FROM MEMORY—

THESE TWO FIGURES DRAWN WITH NO. 2 BRUSH

The Complete Figure

THIS END UP

HERE IS A GOOD CHANCE TO GROUP YOUR FIGURES

NOTICE THE PEN HANDLING ON THIS BUM

The Complete Figure

STUDY THESE FIGURES – COPY THE ONES THAT INTEREST YOU

NOTICE SHADING IN HIS PANTS

NO STANDING BY ORDER OF POLICE

Man In Motion

NOT MANY CARTOONISTS DRAW THE EXAGGERATED TYPE OF CARTOON, BUT DISCOVERING A FEW NUGGETS OF KNOWLEDGE ON THE SUBJECT MAY BE OF GREAT VALUE TO YOU.

DRAWN WITH NO. 2 BRUSH-SHADED WITH PRISMACOLOR BLACK, No. 935

PUT YOURSELF INTO THE POSITION YOU ARE GOING TO DRAW — TRY TO FEEL, IN YOUR MIND'S EYE, THE EXAGGERATED ACTION WHICH IS ABOUT TO APPEAR ON YOUR BLANK DRAWING PAPER

Man In Motion

WALKING FIGURES NO. 1 TO 5
TO BE DONE IN PENCIL....
and REMEMBER — LEFT ARM
FORWARD — RIGHT LEG FORWARD

1.

2.

3.

4.

NOTICE: PENCIL DRAWING
ALMOST COMPLETE BEFORE
INKING IN

5.

NOTICE
GLOVE
LINES

6.

Man In Motion

Man In Motion

WE'VE COVERED THE RUNNING FIGURE TWO LESSONS BACK — NOW LET'S EXAGGERATE!

COPY THESE FIGURES, KEEPING IN MIND THEIR FORMATION RATHER THAN THE DETAIL OF THE FIGURE

Man In Motion

TRY MAKING YOUR FIGURES LOOK LIKE THEY REALLY MEAN WHAT THEY'RE DOING...

RAISE HIM OFF THE GROUND

BACK ARCHED and LEG STRAIGHT

LEG OFF THE GROUND

HEAD FORWARD

ROPE END LIMP

STRAIGHTEN THIS LEG FOR EXTRA PUSH

LEG OFF THE GROUND

WITH THE ADDITION OF A FEW EXTRAS IN YOUR DRAWING, YOU CAN CREATE THE ILLUSION OF EXTREME POWER

Man In Motion

Man In Motion

IT WILL HELP THE ACTION HERE IF THE PICK HANDLE IS SLIGHTLY BENT

GIVE THEM THE TOOLS AND THEY'LL DO THE JOB... DIP INTO YOUR FILES FOR HAMMERS, WRENCHES, ETC. —THEY'LL SUGGEST GOOD ACTION POSSIBILITIES

COPY THESE FIGURES BY FIRST SKETCHING THEM IN THE OVAL and STICK METHOD

Man In Motion

NOTICE HOW HANDS AND FEET THAT ARE CLOSER TO THE FOREGROUND ARE DRAWN LARGER

ALL THESE FIGURES WERE INKED IN WITH A NO. 2 BRUSH

Kids

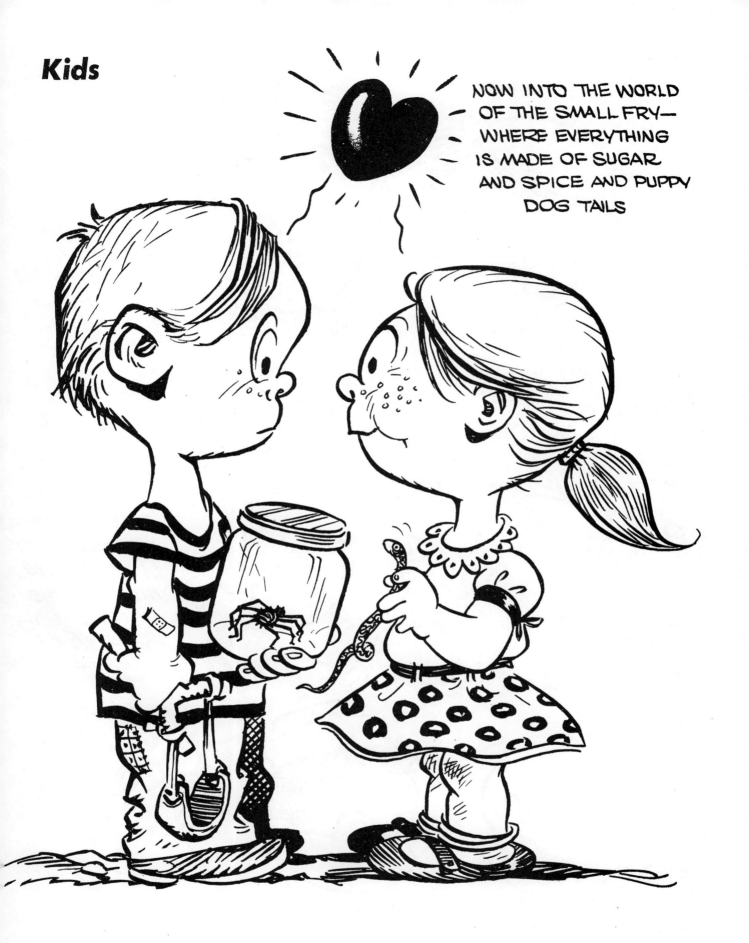

NOW INTO THE WORLD OF THE SMALL FRY— WHERE EVERYTHING IS MADE OF SUGAR AND SPICE AND PUPPY DOG TAILS

Kids

NOTE HOW A CHILD'S HEAD IS DIVIDED AS COMPARED TO A GROWN-UP'S —EYES ARE SET LOWER AS A RESULT OF THE HIGHER FOREHEAD

STUDY AND COPY THESE KID HEADS AND FIGURES... ...GET THE FEEL OF THIS SQUAT LITTLE GUY... THEN DO THE SAME OFF THE FOLLOWING PAGES...

Kids

CLOTHES MAKE THE KIDS...TYPES REVERT TO THEIR APPAREL AS YOU CAN SEE BELOW — REMEMBER, A MAIL ORDER HOUSE CATALOG CAN BE OF GREAT HELP IN DRESSING UP THE LITTLE MOPPETS

Kids

MOMMY— WOT'S A WATT?

I NEED ANOTHER NICKLE

WHAT BOOK, MOM?

COMIC BOOK

WHY DO WE GOTTA HAVE TEETH?

HONEST MRS. SMITH— WE WON'T TACKLE HIM TOO HARD

SHAME ON YOU, GLADYS!

DETAIL OF SLING SHOT

OKAY, I'M READY F'R TRICK OR TREAT

Kids

GROUPING KIDS ISN'T TOO TOUGH—
EACH CHILD LENDS ITSELF TO A
PARTICULAR POSE BASED ON
HIS AGE AND CHARACTER, SUCH AS
THE TOM BOY-TOUGH KID, HERO,
TAGALONG and MANY OTHERS

FIG. A

SKETCH OUT
THESE THREE
GROUPS IN
PENCIL— AS
IN FIGURE A
—THEN FINISH
THEM OFF IN
INK-COLOR
THEIR CLOTHING

Animals

THE ANIMAL LIFE YOU ARE ABOUT TO DRAW IS STRICTLY COMIC — HIGHLY EXAGGERATED IN SOME PARTS AND PERHAPS A BIT OUT OF WHACK IN THE ANATOMY DEPT., *But...*

...BY FOLLOWING A GENERAL FORM, YOU CAN MAKE A DOG LOOK LIKE A DOG... AS YOU SHALL SEE ON THE PAGES TO FOLLOW.

Reproduced from the book The Lovable Mongrel published by All-Pets Books, Inc., Fond du Lac, Wisconsin.

Animals

TWO CIRCLES FOR THE HEAD—

A CIRCLE and OVAL FOR CHEST and LOWER FRAME

ONE PATTERN FOR DRAWING A MUTT SHOULD WORK FOR MOST DOGS

GIVE THIS ONE A WHIRL, THEN WORK ON THE OTHERS BELOW. THE EXPRESSIONS ON THE BOTTOM OF THE PAGE ARE HANDLED LIKE THOSE OF A HUMAN

Animals

BASIC OUTLINE FOR A STRAIGHT DRAWING OF A HORSE

HERE'S AN ANIMAL WHOSE LEGS ARE EXTRA KNOBBY— CARE MUST BE TAKEN TO PLACE THOSE KNOBS IN THE PROPER PLACE—EVEN FOR A COMIC HORSE—

JUNK

VANISHING AMERICANA

Animals

SPACE WILL NOT PERMIT THE
DRAWING OF EVERY TYPE OF
BIRD, BUT WE'LL GIVE YOU A
BASIC OUTLINE FROM
WHICH MOST BIRDS CAN
BE DRAWN

TAIL UP
OR
DOWN

YOU CAN GET A FEATHERY
EFFECT BY MAKING YOUR
OUTLINE WITH A SERIES OF
THIN LINES (SKETCHY)

NOTICE HOW
CLAWS WRAP
AROUND BRANCH
(TWO, FRONT-ONE, BEHIND)

TRY YOUR WINGS
CROSSHATCHING THIS
CROW

MOST BIRDS
HAVE THREE
CLAWS,
BUT—

—THE EAGLE HAS
FOUR-THREE FRONT,
AND ONE BEHIND—

— AS DOES THE
ROADRUNNER →
THIS DESERT BIRD
HAS TWO CLAWS IN
FRONT AND TWO
BEHIND

Animals

JUNGLE ANIMALS FIND THEIR WAY INTO POLITICAL AND SPORTS CARTOONS — HERE WE SHOW TWO VERSIONS OF THE TIGER and THE LION

THE VICIOUS and the VANQUISHED

THIS LION SHADED WITH PRISMACOLOR NO. 935 DRAWN ON GLARCO STIPPLE

LIONS and TIGERS — PLUS MOUSE WERE INKED IN WITH A NO. 2 BRUSH and SHADED WITH HUNT PEN, No. 513

Animals

FARM ANIMALS

COPY THESE FARM ANIMALS - TRY YOUR HAND AT SHADING THEM WITH A NO. 2 BRUSH

Animals

COPY THIS MONKEY, AND YOU'LL NOTICE HOW IT RESEMBLES SOME OF THE WORK IN "THE COMIC FIGURE"

THE BEAR BELOW WILL GIVE YOU A GOOD CHANCE TO BRUSH UP ON YOUR BRUSH WORK

FLATTEN OUT YOUR BRUSH—HOLD ALMOST UPRIGHT TO GET THIS FUZZY EFFECT.

THE TRICK IN DRAWING THIS RATTLER IS TO LAY DOWN HIS LINE OF CENTER IN SOME SORT OF CURVE, THEN ADD THE REST OF HIS TUMMY, PARALLEL TO THE CENTER LINE.

The Women

I BETTER GET OFF THIS PAGE... I DON'T HAVE ANY MAKE-UP ON

THE GIRLS (BLESS 'EM) ARE A FRAGILE LOT— —SO HANDLE THEIR LINES WITH A LIGHT TOUCH— — WHEREAS THE FRAU WITH THE TENDER HEART CAN BE HANDLED WITH A MASCULINE FLAIR

The Women

HERE WE ARE—BACK TO THE DIVIDED OVAL—COPY THIS ONE, THEN TRY A FEW OF YOUR OWN—FOR HAIR STYLES, ETC. LOOK IN THE POPULAR WOMEN'S MAGAZINES

TREAT THE BUST...

...ARMS...

... HANDS...

...and LEGS WITH THE UTMOST REFINEMENT.

73

The Women

WE HAVE SPLIT THE GAL INTO THIRDS — NOTICE THE CENTER BUST LINE IS APPROXIMATELY ½ THE DISTANCE BETWEEN TOP OF HEAD and CENTER OF HIP CIRCLE

1/3

2/3

1

HEAD

SHOULDER

WAIST

WAIST TO JUST BELOW KNEES

LEGS

TOP OF HEAD

BUST LINE

HIP CIRCLE CENTER

MORE GALS WITH A SLIGHTLY COMIC TOUCH — CONSULT YOUR FILES OR WOMEN'S MAGAZINES FOR FASHION SUGGESTIONS

COPY THESE CURVES BEARING IN MIND THAT THE TENDER TOUCH IS IMPORTANT

The Women

COPY THESE GALS IN PENCIL FIRST— THEN INK IN ENTIRELY WITH A No. 2 BRUSH

75

The Women

SOMETHING HAPPENS TO ALL OF US WHEN AGE TAKES OVER— THE GALS BECOME GOOD CHARACTERS FOR THE COMIC ARTIST— HERE ARE A FEW EXAMPLES OF MIDDLE AGE-ITIS

HERE IS A CLUBWOMAN, THROUGH AND TRUE— ALWAYS READY TO READ THE MINUTES OF THE LAST MEETING

THIS GAL WITH THE WASH BUCKET HANDS CAN'T WORRY— SHE'S GOT AN OFFICE TO MOP UP

SHE'S GOING TO WEAR HIGH HEELS IF IT KILLS HER

THIS GAY ONE JUST WON'T GIVE UP

and HERE'S A GAL WHO KNOWS WHAT SHE WANTS

The Women

ON THE SUBJECT OF WOMEN'S CLOTHES, FOLLOW THE FASHION ADS IN YOUR NEWSPAPERS and MAGAZINES ... YOUR WORK WILL ALWAYS HAVE THAT UP-TO-DATE LOOK. NATURALLY, YOU WILL WANT TO CHANGE THE POSE, and IN SOME CASES, THE "COLORING" OF THE MATERIAL.

(ARROWS DENOTE- FROM FASHION FIGURE TO COMIC)

These two figures printed by courtesy of the HIGBEE Co., Cleveland, O.

fashion figure Courtesy of HALLE BROS. CO., Cleveland, Ohio

figure by permissiom of THE MAY CO., Cleveland, O.

77

Stock Types

DISTINCTIVE TYPES ARE IMPORTANT TO A CARTOON... ...POLITICAL CARTOONISTS PROBABLY USE STOCK "TYPES" MORE THAN ANY OTHER ARTIST...

... BUT THERE ARE MANY OTHER TYPES OF COMIC THAT HAVE CERTAIN CHARACTERISTICS — THE FOLLOWING PAGES SHOW MANY TYPES, INCLUDING THE POLITICAL ONES

Stock Types

JOHN Q. PUBLIC
or JOE FANN

FATHER
TIME

LABOR

THE
WORLD

Stock Types

80

Stock Types

THE TWO U.S. POLITICAL PARTIES

IN MANY CASES, THE DEMOCRATIC DONKEY IS DRAWN WITH A HUMAN BODY—THE ELEPHANT, ON THE OTHER HAND, USUALLY CAVORTS IN HIS NORMAL FIGURE

G.O.P.

DEMS

WINTER

ALL FIGURES INKED WITH A HUNT No. 512 PEN — BLACK AREAS WITH NO. 4 BRUSH

← STARVATION, DEATH OR DEVASTATION

Off Beat Comics

OFF-BEAT TYPES ARE FUN TO DRAW... ...LET YOURSELF GO AND THROW CONVENTION OUT THE WINDOW AS FAR AS FORM IS CONCERNED-- --PERHAPS YOU CAN COME UP WITH A BRAND NEW STYLE.

Off Beat Comics

THE "OFF BEAT" CARTOON IS FAIRLY NEW AND VERY POPULAR AS IT IS USED IN PRACTICALLY ALL TYPES OF ADVERTISING—ESPECIALLY TELEVISION...

TV COMICS ARE KEPT VERY SIMPLE——IN MANY CASES, FIGURES ARE DRAWN WITH ONE CONTINUOUS LINE...

...BACKGROUNDS ARE KEPT SIMPLE...

...AND ANIMALS ARE HELD TO A MINIMUM—

—ALL BECAUSE OF THE RIGORS OF FILM ANIMATION — THOUSANDS OF SEPARATE DRAWINGS HAVE TO BE MADE TO PRODUCE A 20 SECOND COMMERCIAL— THEREFORE, KEEP IT SIMPLE !!

Off Beat Comics

NEWSPAPER, MAGAZINE AND DISPLAY ADVERTISERS HAVE MADE GOOD USE OF "OFF BEAT" COMICS — HERE ARE A FEW TYPES THEY EMPLOY...NOTICE THE METHOD USED IN INKING.

SPEED BALL PEN

BRUSH

BRUSH

PEN

BRUSH and PEN

PEN

BRUSH and PEN

PEN

IN SOME CASES THESE COMICS ARE ALMOST CHILDLIKE—BUT TRY YOUR HAND AT IT~ IT'S A SALABLE STYLE

Off Beat Comics

ANIMALS IN COMMERCIAL ART
TAKE ON AN "OFF BEAT" FORM
WITH GOOD RESULTS — COPY
THESE SIMPLE DRAWINGS
YOU'LL GET A KICK OUT OF IT

Off Beat Comics

THIS ODD LOOK IN THE COMIC FIELD HAS CREPT INTO THE GAG PANELS. THE ART YOU SEE BELOW WAS NOT MEANT TO BE FUNNY—BUT SHOWS HOW THE "OFF BEAT" STYLE IS USED TO ILLUSTRATE GAGS.

"OUCH!"

Perspective

FIRST OFF, THIS IS A SIMPLE SCENE OF A HORIZON....
THIS LINE WILL BE CALLED THE HORIZON LINE OR "HL"

— KNOWING OUR "HL", WE WILL PLACE A DOT HERE, (ALTHOUGH IT CAN BE PLACED ANYWHERE ON THE HL) ...AND WE'LL CALL IT OUR VANISHING POINT, OR "VP"

NOW WE'LL PULL TWO LINES DOWN FROM OUR VP — CALLING THEM (A) and (B) THESE TWO LINES FORM THE ROAD... OTHER LINES DRAWN FROM THE VP WILL BE GUIDE LINES FOR OTHER OBJECTS —

FOR INSTANCE — WE DRAW A POST AT THIS POSITION — THEN WE PULL A LINE FROM THE VP DOWN TO THE TOP OF SAID POST — THIS LINE WILL GIVE US THE HEIGHT OF ALL OTHER POSTS GOING INTO THE DISTANCE

HERE WE HAVE A SMALL HOUSE-LIKE STRUCTURE TO ILLUSTRATE HOW TO MAKE USE OF YOUR LINES COMING DOWN FROM THE V.P.

NATURALLY, THE POSTS WILL TEND TO CLOSE IN ON EACH OTHER AS THEY GO OFF INTO THE DISTANCE.

YOU CAN ATTACH BARBED WIRE OR WOODEN PICKETS TO YOUR FENCE POSTS

Perspective

EVEN YOUR LETTERING GOES INTO PERSPECTIVE

SMOKE

VP

HL

NOTICE HOW EACH OBJECT, DIRECTLY AFFECTED BY THE **VP**, GIVES THE FEELING OF DISTANCE. NOTICE, ALSO—OBJECTS IN THE DISTANCE ARE HANDLED MUCH LIGHTER THAN THOSE IN THE FOREGROUND.

HERE AGAIN, THE TELEPHONE POLES TEND TO CLOSE UP ON EACH OTHER AS THEY GO INTO THE HORIZON.

AS WITH THE TELEPHONE POLES—THE FENCE PICKETS BECOME NARROWER AS THEY LEAVE THE FOREGROUND

NOTICE THE MAN'S FEET ARE IN PERSPECTIVE

HL

VP

VP

HL

PERSPECTIVE WILL BECOME SECOND NATURE TO YOU AS YOU CONTINUE TO USE IT... SO COPY THESE EXAMPLES —and REMEMBER THEM

PLACING THE FIGURE IN
Perspective

V.P.
(VANISHING POINT)

YOU'LL SEE MORE OF THE UNDERNEATH OF OBJECTS **ABOVE** THE HORIZON LINE

HORIZON LINE

H.L.

YOU'LL SEE MORE TOPS OF OBJECTS **BELOW** HORIZON LINE

WANTED

V.P.

H.L.

HERE THE ANGLE OF COP'S FEET IS CONTROLLED BY AN IMAGINARY V.P. THAT STARTS FROM ANOTHER POINT ON THE HORIZON LINE

YOU CAN GET THE ILLUSION OF HEIGHT WITH A LOW H.L.

Comic Gimmicks & Props

IN THIS LESSON WE'LL SHOW HOW THE GIMMICKS and "LITTLE MARKS" SET THE MOOD and BRING LIFE INTO YOUR CARTOONS — ALSO, SOME INDOOR and OUTDOOR PROPS USED BY CARTOONISTS

CLOUDS OF SMOKE DENOTE NERVOUS STOGIE SMOKER

BACK VIEW OF SPEEDING CAR — SPEED IS EMPHASIZED BY RAISING BACK END OF CAR

IMPATIENT MISS STARTS FOOT-TAPPING

PROUD PAPA

"CAN'T FIGGER IT OUT!"

Some Comic Strip Slanguage

LEMME GO ——————— LET ME GO
WHATCHA DOIN'? — WHAT ARE YOU DOING?
YOU WUZ? ——————— YOU WERE?
HR-RUMPH! — SOUND OF CLEARING THROAT
GOTCHA! ————— I'VE GOT YOU!
F'R TH' LOVA PETE — FOR THE LOVE OF PETE
KER-PLUNK! — SOUND OF OBJECT HITTING THE GROUND

FINGER THUMPING

Comic Gimmicks & Props

Comic Gimmicks & Props

INDOOR PROPS

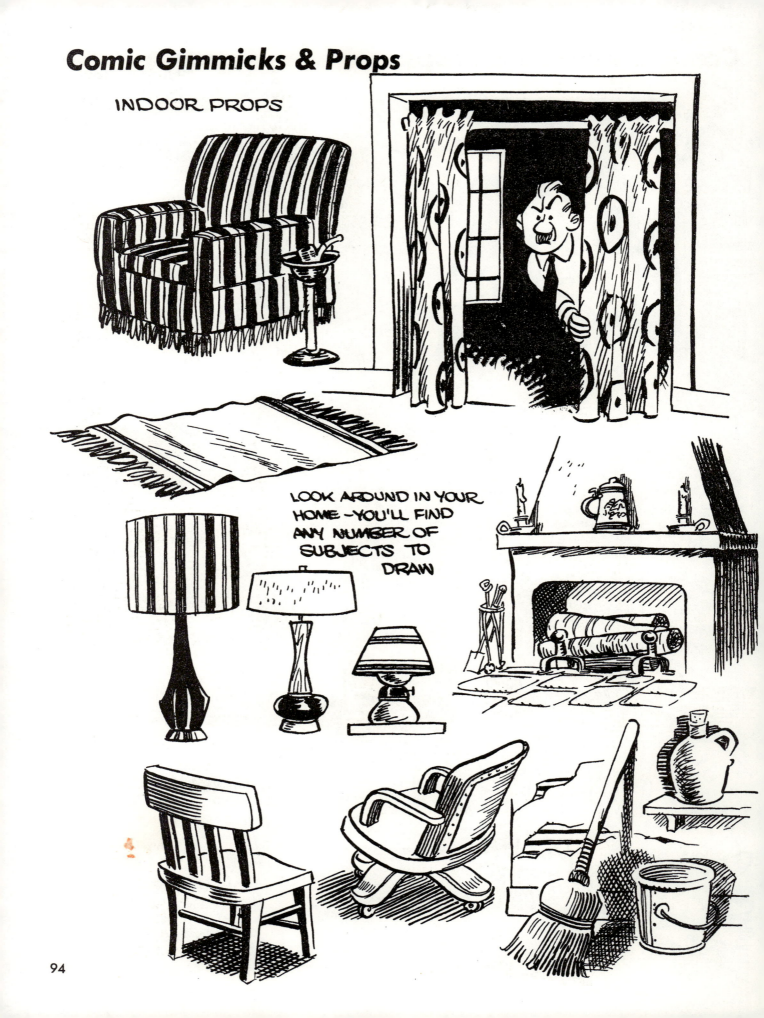

LOOK AROUND IN YOUR HOME—YOU'LL FIND ANY NUMBER OF SUBJECTS TO DRAW

Comic Gimmicks & Props

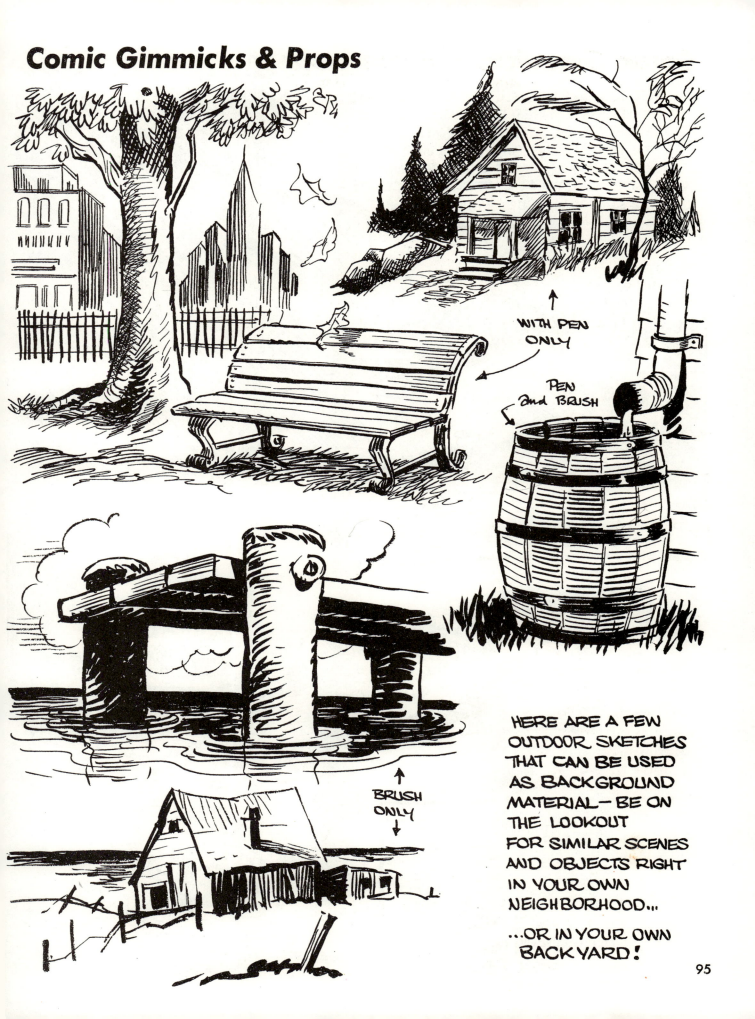

WITH PEN ONLY

PEN and BRUSH

BRUSH ONLY

HERE ARE A FEW OUTDOOR SKETCHES THAT CAN BE USED AS BACKGROUND MATERIAL— BE ON THE LOOKOUT FOR SIMILAR SCENES AND OBJECTS RIGHT IN YOUR OWN NEIGHBORHOOD...

...OR IN YOUR OWN BACKYARD!

Comic Gimmicks & Props

WATER IS A TRICKY SUBJECT... ONE THING TO REMEMBER WHEN DRAWING A LARGE BODY OF WATER SUCH AS A LAKE OR AN OCEAN IS THAT THE BACKGROUND IS DARKER THAN THE FOREGROUND, WHICH IS OPPOSITE TO OTHER OUTDOOR SCENES— COPY THESE SCENES...GET YOUR FEET WET

FIG. 1

DARK HORIZON

LIGHTER FOREGROUND

FIG. 2

A GOOD WAY TO HANDLE A MUDDY ROAD

IN FIG 1. TRY TO WORK IN THE FOAM WITH A BRUSH—LEAVING WHITE AREAS BETWEEN—USE CHINESE WHITE WHERE YOU WILL WANT TO ACCENTUATE HIGHLIGHTS...IN FIG. 2. THE RAIN IS FIRST DRAWN WITH PEN, THEN WHITE IS USED AFTER THE INK DRIES.

Comic Lettering

WATCH IT, JOE!! THEY'RE GONNA TAKE THAT GUY WITH 'EM! HEY!! JOE!! LOOK OUT

ONE OF THE MOST IMPORTANT SEGMENTS OF CARTOONING IS ITS LETTERING AND THE BALLOONS INTO WHICH THE LETTERING APPEARS.

IN MANY CASES A GOOD CARTOON HAS BEEN RUINED AS A RESULT OF A BAD LETTERING JOB — SO BE MOST SERIOUS ABOUT THIS AND PRACTICE QUITE HARD.

THE LARGER TYPE WAS OUTLINED THEN FILLED IN WITH A SMALL BRUSH

TO BE SURE YOUR LINES WILL ALWAYS BE EVEN — TAKE A PIECE OF THIN CARD-BOARD — MARK OFF THE SPACE FOR LETTER-ING AND THE SPACE BE-TWEEN

PLACE IT ON THE LEFT EDGE OF YOUR PAPER — MARK IT OFF — USE A T-SQUARE TO RULE YOUR PENCIL LINES ACROSS YOUR PAPER

YOUR LETTERING GUIDE

HOW CAN I GET ALL OF THIS WORK DONE?

TO INSURE A GOOD JOB, STAY WITHIN THE LINES

PENCIL IN YOUR LETTERING WITH CARE BEFORE INKING IN

IMPORTANT!! KEEP YOUR PENS CLEAN AT ALL TIMES!!

TRY TO SPACE YOUR LETTERING WITH SOME FORM AS IN THIS CASE

THIS TYPE OF BALLOON IS QUITE POPULAR TODAY

WHEN USING THIS TYPE OF BALLOON, WATCH YOUR SPACING

NOTE: — ALL LETTERING IN THIS BOOK WAS DONE WITH No.513 HUNT PEN

Caricatures

THE ART OF CARICATURE HAS BEEN A MOTIVATING FORM OF CARTOONING DOWN THROUGH THE AGES.
IF YOUR DESIRES LEAN TOWARD BECOMING A POLITICAL OR SPORTS CARTOONIST, IT IS ALMOST A MUST REQUIREMENT THAT YOU MASTER THIS FASCINATING FORM OF ART——

NIKITA

CASTRO

IKE

CASEY

PICTURED HERE ARE FOUR LEADERS WHO HAVE BEEN RESPONSIBLE IN SHAPING THE DESTINIES OF THEIR FELLOW MEN

98

Caricatures

... TV'S **JACK PAAR,** WHOSE OUTSTANDING FEATURES ARE HIS SMILE, FOREHEAD, HAIR and CHIN — HIS SQUINT WILL ALSO ADD TO HIS LIKENESS...

..and

JOHN L. LEWIS WHOSE FAMOUS EYEBROWS, UPPER LIP AND FLOWING HAIR ARE EASILY RECOGNIZABLE TRADE MARKS

Caricatures

VICE PRESIDENT
RICHARD
NIXON

...OUR VICE PRESIDENT,
(at this printing) HAS AN OUT-
STANDING NOSE WITH HEAVY
JOWLS and DARK EYES TO MATCH...

...and THE GOVERNOR OF NEW
YORK HAS A GOOD SQUINT
ATTACHED TO HIS WINSOME
SMILE.

GOVERNOR
NELSON
ROCKEFELLER

Caricatures

A PERSON'S FIGURE CAN BE JUST AS EXPRESSIVE AS HIS OR HER FACE... HERE ARE TWO BALL PLAYERS, WHOSE FRAMES ARE AS DIFFERENT AS THEIR BLACK ON WHITE DRAWINGS... ...BUT THEY ADD TO THE TYPE OF CARICATURE THAT IT IS...

IN HIS FIRST WORLD SERIES IN 1947, **YOGI BERRA** HIT THE FIRST PINCH-HOMER IN WORLD SERIES HISTORY!

LOU DARVAS

MICKEY MANTLE...

Gag Panels

THE GAG-TYPE CARTOON WAS ORIGINATED AND USED, FIRST, BY MAGAZINES... THEN, ABOUT TEN YEARS AGO, THE NEWS-PAPERS SAW ITS MERIT, STARTED USING THEM. TODAY, PRACTICALLY EVERY METROPOLITAN NEWSPAPER IN THIS COUNTRY AND ABROAD CARRIES AT LEAST ONE GAG PANEL... AND WITH GREAT SUCCESS.

" MY GAME'S BEEN LOUSY LATELY... I'VE LOST FOUR NEW CLIENTS SO FAR THIS WEEK ".

" SAY, DAD, Y'KNOW THAT ONE COW WE USETA HAVE ? "

IN THIS LESSON WE'LL SHOW YOU THE VARIOUS TYPES OF PANELS THAT ARE SELLING TODAY— THE IMPORTANCE OF PANEL COMPOSITION—TYPES OF SHADING, AND A VISIT WITH A WELL KNOWN MAGAZINE GAG PANELIST.

" SURE I LIKE SPORTS—AND I'D LIKE TO GO OUT FOR TH' POLE-VAULT ".

Gag Panels

EVEN IF YOU HAVE A BRIGHT SNAPPY GAG, YOUR PANEL WON'T CATCH THE READER IF THE COMPOSITION IS OFF....

...IN OTHER WORDS, YOU SHOULD KNOW HOW TO PLACE YOUR COMIC FIGURES IN A PANEL SO THAT THE EYE IS QUICKLY FOCUSED ON THE CRUX OF THE GAG.

PATENT OFFICE →

NOTICE—BOTH PATENTS ARE FACED IN THE SAME DIRECTION SO THE DUAL COMPARISON CAN BE QUICKLY NOTED

HERE WE HAVE TWO DIRECTIONAL ANGLES THAT ARE FOOL-PROOF IN DIRECTING THE EYE FROM SPEAKER TO SUBJECT

AWRIGHT! AWRIGHT!! LET'S GROW! GROW! GROW!

" WOW! IT WAS SO HOT T'DAY, I WOULDN'T'VE MINDED A LITTLE SNOW NOR RAIN NOR SLEET NOR GLOOM OF NIGHT."

Gag Panels

IN STARTING THIS OFF-BEAT TYPE OF GAG CARTOON,
THREE PRELIMINARY SKETCHES WERE MADE AS
SHOWN AT THE RIGHT—PICKED No. 3 AS THE READER'S
NATURAL COURSE IS TO LOOK FROM LEFT TO
RIGHT—OR FROM PERSON TO CAR CARD...AFTER INKING
THE FIGURES WITH A No. 2 BRUSH, I USED A FLAT (KORN'S
LITHOGRAPH) CRAYON No. 4 FOR SHADING

Gag Panels

A "WASH" DRAWING ON ILLUSTRATION BOARD"

AFTER YOU HAVE YOUR INK LINES DOWN IN EITHER PEN OR BRUSH – ERASE THE PENCIL WORK WHEN THE INK IS DRY – YOU SHOULD HAVE A TUBE OR JAR OF LAMP BLACK – I PREFER THE JAR AS THERE IS NO WASTE.

NOW YOU ARE READY TO LAY IN THE WASH

MAKE YOURSELF THIS CONTAINER – IT'S MIGHTY HANDY FOR CLEAN AND DIRTY WATER IN ONE SPOT – USE A MASON JAR SET INTO A LARGER BOWL –

CLEAN WATER
CLEAN BRUSHES HERE
MASON JAR

DIP YOUR BRUSH INTO THE CLEAN WATER – WORK IT INTO YOUR LAMP BLACK – TEST IT ON ANOTHER PIECE UNTIL YOU HAVE THE SHADE OF GREY YOU WANT – WHEN YOU FIGURE OUT WHERE YOU WANT THE LIGHT AND DARK AREAS, LAY IT IN – IF ONE AREA IS TOO LIGHT, LAY ON ANOTHER COAT AFTER THE FIRST IS DRY – HERE'S THE RESULT →

Gag Panels

Gag Panels

MISS PHIBBS SECRETARIAL SCHOOL

and HERE'S HOW A GAG CARTOONIST WORKS—AS TOLD BY GEORGE, HIMSELF...

"Started in high school . . . sold to College Life . . . College Humor . . . Ballyhoo . . . in 1929. Started to sell majors in 1934 . . . Collier's, Saturday Evening Post.

"I still love cartooning . . . it beats working! I do all my own set ideas for This Week magazine. I use gag men for about half of my stuff, but when I have to, I can do all my own gags. I've got ideas I haven't used yet.

"I start working by sketching little thumbnail sketches on a yellow legal pad and have a lot of sharpened pencils handy. Wish I could sharpen my wits as easily. Sometimes I get the drawing first . . . sometimes the gag line first. When I get enough ideas, I do my roughs on good bond paper, drawing lightly in pencil, then finishing up with a fountain pen and India ink.

THIS IS THE ACTUAL SIZE OF THE FIGURE SHOWN BELOW

THIS GAG APPEARED IN THE AMERICAN LEGION MAGAZINE

"JUST CHECKING—I HAVE ONE OF YOUR GRADUATES WORKING FOR ME!"

GEORGE WOLFE

107

Gag Panels

"My finishes are merely traced from the roughs by using a light box which is built into my drawing table. Consequently, my finishes are never too large but I try to get a good border of white around so that it *looks* bigger. Sometimes I draw lightly in blue pencil . . . no erasing necessary. . . .

NOTICE THE ECONOMY OF LINE IN WOLFE'S WORK...
...HIS EVERY LINE MEANS SOMETHING and HIS BLACK AREAS ARE SUBTLY APPLIED WITH GREAT FINESSE.

from THE AMERICAN LEGION MAGAZINE

"HERE'S THE SECOND PAGE OF MOTHER'S LETTER, DEAR!"

GEORGE WOLFE

Gag Panels

"I can't impress too strongly the necessity of practicing regularly. I doodle constantly and quite often use a doodle in my published work. I know I am one of the few cartoonists who were in business twenty or more years ago who still practices. I like to draw and observe the work of the new cartoonists very closely.

YOU'LL FIND THE RESULTS OF THESE GEORGE WOLFE DOODLES IN PARTS OF HIS CARTOONS THAT APPEAR ON THESE PAGES... THEY ARE ACTUAL SIZE REPRODUCTIONS

Gag Panels

"I always try to glean something from the newcomers. After all there is a good reason for them selling. Perhaps I can learn. After all, the cartoonist has to be young at heart . . . no room for the guy who lives in the past. No use practicing the bunny hop when everyone is doing the cha-cha-cha!

"Being a cartoonist has been fun. I've never really hit the top brackets as far as earning is concerned. I've enjoyed, however, the highest prices paid to free lance cartoonists by top magazines.

THE FIGURES ABOVE WERE REPRODUCED IN THEIR ORIGINAL SIZE.

•

THIS GAG MADE ITS APPEARANCE IN THE SATURDAY EVENING POST

"IF YOU WANT TO SEE SOME ACTION—OPEN THE ICE BOX!"

Gag Panels

"My advice to aspiring cartoonists is this:

1. Get a good formal art training.
2. Do anything that will lead to people getting to know your work. Work for free if necessary.
3. Don't worry about technique.
4. Be neat in appearance as well as work.
5. Study what makes other cartoonists good.
6. Don't be afraid to submit to the big markets first . . . they're just as easy or as hard to sell as the small mags.
7. Try to do your own gags . . . it's a nice feeling not to have to split your pay.

In closing let me say that there is no substitute for hard work or hard cash!"

GEORGE WOLFE

PORTION OF THE ACTUAL SIZE OF THIS CARTOON WHICH HAD APPEARED IN THE AMERICAN MAGAZINE.

" WHY, EVELYN —— HOW CLEVER ! "

The Comic Strip

HAFF NELSON—Bugs, Incorporated

COMIC STRIPS HAVE BEEN PROGRESSING FOR THE PAST 55 YEARS—THEY WILL CONTINUE TO PROGRESS FOR A LONG, LONG TIME. AS LONG AS THERE ARE CREATORS WITH VIVID IMAGINATIONS AND A FLAIR FOR WIT AND HUMOR, THE MARKET PLACE FOR THE COMIC STRIP WILL NEVER BECOME CROWDED.

—HEREWITH IS A STRIP THAT SUFFERED THE PANGS OF A POST-WORLD WAR II NEWSPRINT SHORTAGE...

—TAKE IT FOR WHAT IT WAS— IT HAD ITS LOYAL READERS WHO SEEMED TO ENJOY

THE ANTICS OF THIS ROLY—POLY CAB DRIVER—EX-WRESTLER.

THE REPRODUCTION ABOVE IS THE SAME SIZE AS IT APPEARED DAILY IN THE NEWSPAPERS—

THIS PORTION AT THE LEFT IS THE EXACT SIZE OF THE ORIGINAL DRAWING WHICH WAS MADE <u>TWICE</u> THE SIZE OF THE REDUCED STRIP

The Comic Strip

GETTING STARTED ON A COMIC STRIP IS NOT AN EASY TASK—YOU MUST PUT YOUR HEART AND SOUL INTO IT... SINCERELY BELIEVE IN IT... STAY WITH IT... AND ABOVE ALL — NEVER BECOME DISCOURAGED WHILE WORKING ON IT!

ADVENTURE Family FANTASTIC KIDS ETC.

FIRST OFF, MAKE A THOROUGH STUDY OF THE STRIPS THAT ARE CURRENTLY POPULAR TODAY...

...AND NOW THE TOUGHEST PART ...GETTING THE **IDEA**!

...TRY TO FIGURE OUT WHAT "TYPE" OF STRIP WOULD SUIT YOU BEST— WOULD IT BE ADVENTURE, GIRL, KIDS, FANTASTIC, FAMILY OR A PANTOMIME STRIP? OR WILL IT BE A "**DIFFERENT**" COMIC STRIP?

REMEMBER—EACH OF THESE "TYPES" CAN BE EXECUTED IN A COMIC STYLE...

THE BEST SOURCE FOR IDEAS IS LIFE ITSELF... KEEP IN CONSTANT TOUCH WITH WHAT GOES ON IN EVERY ASPECT OF LIFE. THE ONE-PANEL TYPE OF STRIP SHOWN BELOW GIVES YOU AN IDEA OF WHAT CAN BE DONE WITH A GROUP OF NEIGHBORHOOD KIDS.

The Comic Strip

WE WILL START LAYING OUT A STRIP, BEARING IN MIND, THAT BOTH THIS PAGE AND THE OPPOSITE PAGE 115 WILL BE TREATED AS ONE SHEET OF PAPER— LET US ASSUME THAT YOU HAVE YOUR CAST OF CHARACTERS...
...IN THIS CASE, THE MAIN CHARACTER, "HAFF NELSON" (PG. 112) HAS JUST HAD A TUSSLE WITH HIS ENEMY "PEACH FUZZ"— THIS IS THE SECOND OF A TWO DAY SEGMENT OF CONTINUITY...

Ⓐ

Ⓑ

The Comic Strip

TAKE A FULL SHEET OF 2 OR 3 PLY BRISTOL BOARD - DIVIDE IT TO GET AS MANY STRIPS AS YOU CAN FROM IT... THE STRIP SHOULD MEASURE 16"x4¾ - ADD AN INCH ALL AROUND FOR A BORDER — NOW DIVIDE IT IN HALF ALLOWING A ¼" SEPARATION. GET YOUR LETTERING GUIDE (SEE PAGE 97) PLACE IT ON LEFT SIDE — MARK OFF, AND WITH T-SQUARE, RULE DOWN YOUR GUIDE LINES FOR LETTERING (FIG Ⓐ) — START PENCILLING-IN YOUR ACTION TAKING AS MUCH SPACE AS YOU WILL NEED FOR EACH PANEL...ROUGH IN YOUR LETTERING AS YOU GO ALONG —

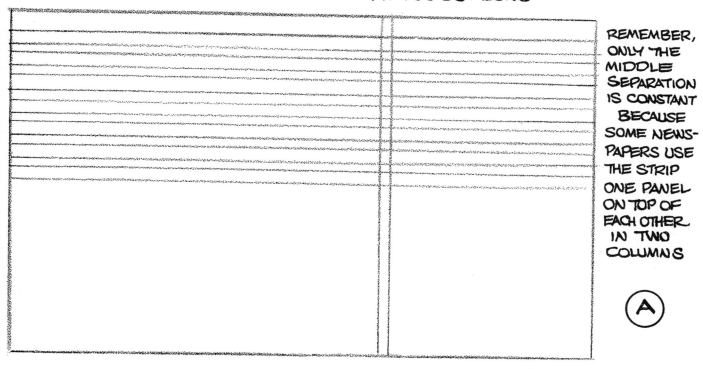

REMEMBER, ONLY THE MIDDLE SEPARATION IS CONSTANT BECAUSE SOME NEWSPAPERS USE THE STRIP ONE PANEL ON TOP OF EACH OTHER IN TWO COLUMNS

Ⓐ

Ⓑ

CONTINUED →

The Comic Strip

NOW THAT YOUR FIGURES ARE PRETTY WELL PENCILLED IN—START INKING. FOR YOUR LETTERING AND OUTLINES OF FIGURES, I WOULD SUGGEST THE ALL-AROUND PEN, HUNT No. 513....IT WILL GIVE YOU A GOOD EVEN OUTLINE PLUS A GOOD LETTERING JOB. IF YOU HAVE A FAVORITE PEN OF YOUR OWN USE IT. BE SURE TO INK IN YOUR LETTERING BEFORE ANYTHING ELSE! INK IN IN THIS ORDER: LETTERING—BALLOONS—FIGURES—BACKGROUND and THEN BORDERS. DON'T HURRY THIS PART...SPEED WILL COME LATER.

The Comic Strip

NOW LET'S LOOK AT STRIP Ⓑ. COMPARE IT WITH STRIP Ⓐ. NOTICE WHERE, AND HOW THE SHADING WAS APPLIED — NOTICE THE ACTION LINES IN THE SECOND PANEL WHICH DENOTE SHAKING OF THE LEG ... NOTICE THE LINES OF MOTION IN PANEL THREE AND THE LEATHERY APPEARANCE OF HAFF NELSON'S JACKET — HIS PANTS ARE SOLID BLACK WHICH MAKES HIM A STAND OUT — AFTER "COLORING" THE CLOTHES, THE STRIP IS COMPLETED WITH GROUND AND BACKGROUND SHADOWS.

Ⓐ

Ⓑ

The Comic Strip

THIS COMPLETE WEEK OF STRIPS SHOWS HOW THE CONTINUITY CAN SUSTAIN THE INTEREST. NOTICE, THESE STRIPS USE ONLY THREE PANELS A DAY.

HAFF NELSON—Here We Go Again!

By Lou Darvas

HAFF NELSON—Eureka!

HAFF NELSON—Anything Like a Taxi Meter?

The Comic Strip

HAFF NELSON—Unveiling

By Lou Darvas

HAFF NELSON—One Track Mind

HAFF NELSON—Needle in a Dump Stack

119

The Comic Strip

HERE IS THE TYPE OF "KID" STRIP THAT HAS BECOME QUITE POPULAR IN THE LAST FEW YEARS. "SIMPLICITY" IS THE BY-WORD IN THIS CASE.

Kid strips and panels have flooded the newspaper market, but there will always be room for a winner!

— Who knows — you may come up with another "PEANUTS", "NANCY", "HENRY" or "DENNIS THE MENACE!"

THIS IS THE ACTUAL SIZE OF ONE OF THE PANELS REPRODUCED ABOVE.
IT WAS DRAWN TWICE AS LARGE. STUDY THE LINES FOR REPRODUCTION AND NOTICE HOW THE "AIR" BETWEEN THE PEN LINES KEEPS THE STROKES FROM RUNNING TOGETHER

A HUNT PEN No. 513 WAS USED.

The Comic Strip

AN "OFF BEAT" TYPE OF STRIP YOU MAY LIKE TO DEVELOP —THE GIMMICK?...
...THE LITTLE GUY ALWAYS GETS INTO A JAM TRYING TO BE SOMEONE HE'S NOT.

IT SEEMS THAT THROUGH THE YEARS NOTHING YET DEVISED BY THE NEWSPAPER INDUSTRY HAS EQUALLED THE MAGNETIC POWER OF THE COMIC STRIP. IT IS TRULY A MEDIUM TOWARD WHICH A BUDDING YOUNG CARTOONIST SHOULD ENERGETICALLY STRIVE. IF YOU HAVE A BURNING DESIRE TO CREATE A FEATURE, BY ALL MEANS, TACKLE IT... THE REWARDS, IN MANY CASES, ARE GREAT!

A ONE-A-DAY PANEL THAT LOOKS INTO THE FUTURE CONCERNING A CONVERSATION OF THE PAST

PART OF SUBURBIA LIFE IN A ONE-PANEL-TYPE OF STRIP —OTHER CATEGORIES COULD BE "THE COMMUTERS"..."NEIGHBORS"..."THE MAGIC BOX" and "SHOPPING CENTER".

The Sports Cartoon

YOU'LL NOT FIND A GREATER VARIETY OF
ACTION ANYWHERE, RHYTHMIC OR
OTHERWISE, THAN IN THE WORLD
OF SPORT.
THE SPORTS CARTOON IS AS
DRAMATIC AS LIFE ITSELF AND
IN THE FOLLOWING PAGES WE'LL
TRY TO WHIP UP YOUR INTEREST IN
THIS FIELD OF DRAWING THE GAME.

Duel in the Sun

By LOU DARVAS

THIS IS AN EXAMPLE OF A CARTOON THAT NEEDED NO WORDING... THE YANKEE BIG GUNS OF '58 WERE RIDING ROUGH SHOD OVER THE REST OF THE LEAGUE AND WERE HEADED TOWARD INDIAN TERRITORY FOR A VITAL SERIES AGAINST THE PO' LITTLE REDSKINS... THIS WAS A TAKE-OFF ON THE POPULARITY OF TV WESTERNS.

The Sports Cartoon

IN THE FIELD OF SPORTS CARTOONING, A PORTRAIT OF A POPULAR SPORTS FIGURE, AIDED BY COMICS, IS A GOOD FEATURE. AS TIME IS AN IMPORTANT FACTOR IN THE BUSINESS, AN INSTRUMENT CALLED THE PANTOGRAPH IS USED, MERELY TO OBTAIN A PROPORTIONATELY ACCURATE PENCIL OUTLINE OF THE PHOTOGRAPH TO BE DRAWN.

THIS INSTRUMENT IS SIMPLE TO USE. FASTEN DOWN YOUR PHOTO and PAPER WITH THUMB TACKS AS SHOWN BELOW—THE PANTO GOES TO THE LEFT. AFTER ADJUSTING THE RODS FOR ENLARGEMENT, FOLLOW THE PHOTO WITH THE METAL POINT (A) BY GRIPPING THE PENCIL POINT (B)...USE AN "H" PENCIL LEAD IN THE HOLDER (B)

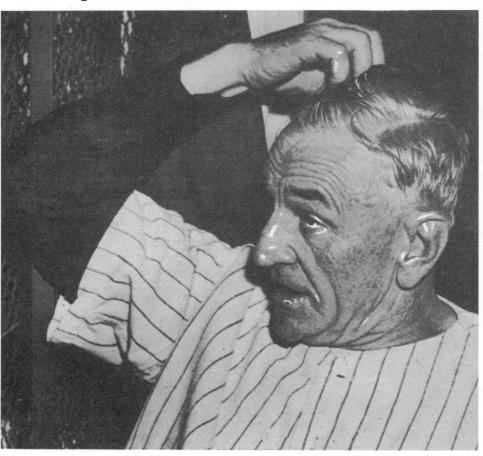

IMPORTANT! YOUR DRAWING PAPER FOR THE CASEY STENGEL HEAD SHOULD BE "GLARCO STIPPLE" (FINE GRADE)

WE SET THE PANTOGRAPH TO ENLARGE THE STENGEL PHOTO A LITTLE UNDER TWICE THE SIZE. THIS WAS DONE AT POINTS (1) and (2)

BY CHANGING THE LOCATION OF THESE TWO PIVOTS, YOU CAN ADJUST THE INSTRUMENT TO ENLARGE A PHOTO TO ALMOST ANY SIZE

The PANTOGRAPH

PHOTOGRAPH (A)

DRAWING PAPER

YOU DESIRE— EACH ROD HAS A SET OF CORRESPONDING NUMBERS WHICH DETERMINE THE AMOUNT OF ENLARGEMENT (i.e., NO.2 ON THE ROD MEANS TWICE THE SIZE)

The Sports Cartoon

(NOTE: YOU CAN PURCHASE A PANTOGRAPH AT ANY ART SUPPLY STORE)

NOW WE'LL BEGIN...... BY FOLLOWING THE PHOTO WITH POINT (A), LIGHTLY DRAW WITH RIGHT HAND HOLDING POINT (B) ALL OUTLINES — OUTLINES OF SHADOWS, EYES, PUPILS OF EYES, HIGHLIGHTS ON NOSE, EARS, LIPS, CHIN,...WRINKLES IN FACE AND HANDS, FOLDS IN CLOTHES, AND DETAILS, LIKE BUTTONS, BUTTON-HOLES, ETC. STUDY THIS DRAWING AGAINST THE PHOTO ON THE OPPOSITE PAGE.

The Sports Cartoon

Ⓐ

REMOVE THE PANTO, AND THUMBTACKS FROM PHOTO AND DRAWING PAPER —
USE A NO. 4 BRUSH AND SPREAD IT OUT AFTER DIPPING INTO INK... HOLD THE BRUSH
FAIRLY HIGH AND START ON THE HAIR (FIG. A). LEAVE SOME HIGHLIGHTS IN THE HAIR.
NOW DO THE EYEBROWS WITH SAME METHOD BRING THE BRUSH TO A POINT AND
HIT THE REST OF FACE, REMEMBERING ONLY TO BRUSH IN THE DARKEST LINES AND
FILL IN THE DARKEST SHADOWS WITH SOLIDS — DO NOT ERASE A THING!

The Sports Cartoon

FLAT PART OF FINGERS

NOTE CRAYON WORK IN HAIR

NOTICE CRAYON LINES TURNING

CRAYON LINES SHOULD BE DRAWN IN SAME DIRECTION AS FACE TURNS

FLAT AREA HERE

YOUR PENCIL FOR ALL SHADING SHOULD BE A KOH-I-NOOR FLEXICOLOR No. 60 (BLACK). CUT IT IN HALF SO YOU CAN USE IT ALMOST FLAT... START ON THE FOREHEAD AND WORK DOWN...WORK YOUR CRAYON PENCIL IN THE SAME DIRECTION AS THE CONTOURS OF THE FACE OR HANDS... START LIGHTLY IN ONE AREA, THEN GO BACK AND HEAVY UP WHERE NECESSARY ALWAYS CHECKING WITH PHOTO. NOTE: TO HEAVY UP AN AREA, GO OVER IT SEVERAL TIMES, PRACTICE ON A SCRAP OF PAPER.

HOLD PENCIL ALMOST LEVEL

The Sports Cartoon

YOU SHOULD HAVE THE FACE PRETTY WELL COVERED — HIGHLIGHTS SHOWING, LIGHT AREAS ARE WHERE THEY SHOULD BE, DARK TONES IN THEIR PLACE, HAIR AND DARK SLEEVE JUST ABOUT FINISHED — NOW LOOK IT OVER — YOU MAY WANT TO LEAVE IT AS IS, BUT THERE IS STILL A LITTLE MORE TO DO — MOSTLY, TO GO OVER WHAT YOU HAVE ALREADY WORKED ON... THE UNIFORM IS STILL UNTOUCHED AND WILL BE THE LAST OF THE CRAYONING.

The Sports Cartoon

THE PORTRAIT IS COMPLETED — NOTICE THE LIPS, CHIN, UPPER LIP, AND PARTS OF THE HAND WHICH WERE WORKED ON JUST A BIT MORE... THE EAR WILL REMAIN AS IS — THE HAIR HAS A FEW MORE DARK AREAS, and CHINESE WHITE, APPLIED WITH A No. 2 BRUSH, WILL BRING OUT THE GREY AREAS and SILVER STRANDS. CHINESE WHITE WAS ALSO USED TO EMPHASIZE WRINKLES AROUND THE EYES.... THE UNIFORM IS CRAYONED.

The Sports Cartoon

AN EXAMPLE OF A LIGHT SPORTS IDEA — DONE ON GLARCO
STIPPLE AND EMPLOYING THE USE OF BOTH BRUSH and PEN WORK..
... SHADING WAS APPLIED IN LARGE FIGURE and IN CLOTHES OF
THE OTHER COMICS...THE ORIGINAL SIZE OF THIS CARTOON
WAS 13" WIDE BY 15" DEEP

(BRUSH USED ON LARGE FIGURE WAS No. 4 ... PEN USED - HUNT No. 513 — CRAYON WORK - 935 PRISMACOLOR BLACK)

The Sports Cartoon

YOU MUST CARRY THE READER THROUGH TO THE "SNAPPER" BY MAKING HIM READ, FIRST, LEFT TO RIGHT, THEN DOWN and then BACK TO LEFT TO RIGHT... THE LARGE FIGURE AT THE TOP IS USED TO ATTRACT THE READER... THE PROCESS CAN BE REVERSED, WHEREBY THE ATTENTION GETTER WOULD BE LOCATED AT THE LOWER RIGHT WITH THE START MADE BY THE SMALLER FIGURES AT THE TOP.

The Sports Cartoon

IT WOULD BE A GOOD IDEA TO BUY A FEW GOOD SPORTS MAGAZINES THAT HAVE PHOTOS OF SPORTS FIGURES WHICH CAN BE USED FOR PANTOGRAPH PURPOSES.

DRAW THEM UP, READ THEIR STORIES AND MAKE UP CARTOONS SUCH AS THIS JOB OF ARCHIE MOORE

NOTE: THIS WAS DONE IN MUCH THE SAME MANNER AS THE STENGEL PIECE, EXCEPT... IT WAS DRAWN ON THE OPPOSITE SIDE OF THE GLARCO STIPPLE PAPER

HE'S 36...HIS LEGS AIN'T SO HOT, AN' THASS BAD!!

JOEY MAXIM...

..PONDERS...

..WHILE...

HE K.O.ED BIVINS THREE TIMES!! AN' THASS GOOD!

..TRAINING...

...FOR HIS FORTHCOMING BOUT WITH.. ARCHIE MOORE WHO HAS WAITED EIGHT YEARS FOR A CRACK AT THE LIGHT-HEAVY-WEIGHT TITLE.....AND THE SMART MONEY IS SAYING HE'LL KNOCK THE CROWN OFF JOEY'S HEAD!

BETTER TAPE IT ON GOOD!

LOU DARVAS

BRUSH USED ON FACE...NO. 4 - PENCIL CRAYON USED-KOH-I-NOR FLEXICOLOR,NO.60 PEN USED FOR COMICS and LETTERING, NO.513, HUNT PEN

The Sports Cartoon
Inklings

By Lou Darvas

THE ABOVE SPORTS PAGE FEATURE HAS BEEN AN EVERY-NOW-AND-THEN SERIES USING QUOTES FROM THE WORKS OF THE "BARD OF AVON".

THE STRIP BELOW WAS USED TO PUBLICIZE THE OPENING OF A LOCAL RACE TRACK...IT WAS SET ON TOP OF THE SPORT PAGE IN EIGHT COLUMNS.

The Sports Cartoon

WHEN A CHANCE COMES UP TO RAM HOME AN IDEA...YOU JUMP ON IT WITH EVERYTHING YOU'VE GOT....IN THIS CASE, THE INDIANS HANDED THEIR ARCH-RIVALS, THE YANKEES, A DOUBLE BLOW ON A SUNDAY...SO NOT ONLY DID THE TRIBE LOWER THE YANKS LOWER INTO THE STANDINGS,...WE DROVE HOME THE RESULT DEEP INTO THE HEARTS OF INDIAN FANS

THIS DRAWING EXECUTED ENTIRELY WITH NO. 4 BRUSH and CRAYON WORK WITH A PRISMACOLOR BLACK PENCIL NO. 935.

GRASS AREA AND FLASH MARKS PULLED OUT WITH CHINESE WHITE.

The Sports Cartoon

TWO MORE EXAMPLES OF CARICATURING WITH THE FULL FIGURE... IN THE CASE OF AL **LOPEZ**, BELOW, THE DRAWING WAS MADE IN ANTICIPATION OF AN INDIAN VICTORY...THE SPACES ABOVE THE CHEWED-UP SOCK AND SCISSORS WERE TO BE USED FOR THE SCORE and NUMBER OF GAMES WON RESPECTIVELY...

(NOTE: THE INDIANS LOST)

area for score

area for number of games won in a row

BOB TURLEY, ...YANKS CHIRPIN' ABOUT BAGGING EX-ORIOLE

4 GAMES BEHIND

AL LOPEZ

BOB TURLEY WAS TO MAKE HIS FIRST APPEARANCE AGAINST THE INDIANS AS A YANKEE...THUS, THIS DRAWING, WHICH WAS MADE A THREE COLUMN PIECE OF ART.
BOTH DRAWINGS WERE INKED IN WITH A NO. 4 BRUSH—CRAYONED WITH PRISMACOLOR PENCIL NO. 935

SPORT CARTOON WITH AN EDITORIAL FLAVOR—SOCKS HOME A MESSAGE AGAINST ORGANIZED BOXING.

ALL WORK WAS DONE WITH A No. 4 BRUSH ON GLARCO STIPPLE ... SHADING HANDLED BY No. 4 KORN'S LITHOGRAPHIC CRAYON (A CRAYON STICK, MEASURING 2" LONG by ¼ SQUARE THAT CAN BE USED ALMOST FLAT ON LARGE AREAS AS ON THE SHIRT CUFF AND GLOVE. GOOD RESULTS CAN BE HAD BY BREAKING A STICK IN HALF AND USING IT "CLOSE-UP."

The Political Cartoon

THE EDITORIAL PAGE CARTOON IS INTENDED TO DEPICT, AT A GLANCE, A CONVINCING REVIEW OF CONTEMPORARY WORLD HISTORY. THE CARTOONS ON THIS PAGE WERE DRAWN BY HAL TALBURT, ONE OF THE GREATEST POLITICAL CARICATURISTS OF THE DAY.

THE POLITICAL CARTOONIST IS TRULY A NEWSPAPER REPORTER WITH PEN AND INK. HE MUST HAVE A GOOD SENSE OF HUMOR ALONG WITH HIS ABILITY TO DRAMATIZE IDEAS THAT WILL AMUSE AS WELL AS INFORM THE READER. SUCH A MAN IS HAL TALBURT, AS WE SHALL SEE IN THE ENSUING PAGES.

The Political Cartoon

GOOD COMPOSITION IN A POLITICAL CARTOON IS <u>MOST IMPORTANT</u> AS IT DIRECTS THE READER'S ATTENTION TO THE <u>FOCAL POINT</u> OF A CARTOON.

HERE, TALBURT HAS USED A CIRCLE TYPE OF COMPOSITION. IT ROTATES THE ATTENTION FROM ANY POINT.

AND FOR THIS HE EXPECTS A RETURN BOOKING?

ALL ABOARD FOR THE NEXT TRIP, FOLKS,

THE CARTOON AT THE RIGHT HAS A TRIANGULAR SIGHT LINE WITH IMPORTANT POINTS AT ALL THREE CORNERS.

The Political Cartoon

HEADED FOR THE INDEPENDENCE DAY PARADE.

TALBURT'S CARTOON AT THE LEFT IS AN "EYE-LEVEL" HEAD-ON TYPE OF COMPOSITION WITH AN EYE LINE DIRECTED FROM UPPER LEFT TO LOWER RIGHT.

SOMETHING TO THINK ABOUT!

ONE OF THE MOST POPULAR FORMS OF COMPOSITION IS TO DIRECT THE EYE DOWN FROM AN UPPER CORNER TO AN OPPOSITE LOWER CORNER AS IN THIS CASE →

The Political Cartoon

THERE YOU ARE, MY GOOD MAN —

—THIS WILL KEEP YOU DRY!

LIFE GUARD

END TO WILD SPENDING

HIGHER DEBT CEILING

RED INK

—TALBURT—

WHEN TALBURT HAS HIS IDEA PRETTY WELL SET, HE SELECTS A PIECE OF GLARCO STIPPLE PAPER AND MEASURES OFF AN AREA, 9½" X 11½"

THIS, THEN, IS HIS WORKING SPACE. HE "ROUGHS" IN THE IDEA WITH A HARD PENCIL, AFTER WHICH HE USES A SOFT PENCIL MUCH LIKE THE PRISMACOLOR No. 935 TO FINISH UP THE JOB AS SHOWN HERE.... TAL NEVER USES A PEN OR BRUSH. NOR DOES HE USE INDIA INK!

●

THIS IS THE REDUCED SIZE FOR WHICH HE WORKS....A PORTION OF THE ACTUAL SIZE IS SHOWN ON THE OPPOSITE PAGE

THE ARTICLE BELOW IS AN EXCERPT TAKEN FROM A STORY WRITTEN BY FRANK ASTON...IT APPEARED IN THE OFFICIAL SCRIPPS-HOWARD HOUSE ORGAN, "SCRIPPS-HOWARD NEWS."

● As Tal tells it, he works one hour a day. Where his 60 minutes of labor fits his schedule is not clear.

About 10:30 a. m. he bustles into the Scripps-Howard Newspaper Alliance offices. Out of a wall box slugged "Talburt" he snatches his mail which he forgets to read unless he senses it's from a friend.

Peeling to shirt sleeves "in there," he reads newspapers for about an hour in privacy. This seclusion is no doing of his, but of his principals who exert themselves to spare him the penalty of his own sociability.

For the next hour or so he may wander around the place discussing the day's affairs, or he may sit down and wait for his brain to take over.

The third hour is devoted to editorial discussion or to staring at his pet tower and reminding his brain that time's aflying.

Then comes 60 minutes during which he draws the next day's cartoon. He always is done by 2:30 p. m. because, as he says, that's when The News engraving department must have it, "no matter whether I've finished it or not." The News processes, mats and proofs his product so that it is ready for airmail before 5 p. m. "It used to be I could take my time and work all afternoon, but the doggone airships ruined everything."

The Political Cartoon

—THIS WILL KEEP YOU DRY!

HIGHER DEBT CEILING

LIFE GUARD

END TO WILD SPENDING

NOTICE, IN THIS ACTUAL SIZE REPRODUCTION, HOW TALBURT MAINTAINS THE SIMPLICITY OF LINE AND MINIMUM OF SHADING.

HIS CARTOONS ARE A FAVORITE OF PEOPLE IN A HURRY, AND BECAUSE THE DRAWINGS ARE SIMPLE, THEY STRIKE HOME WITH WHAT'S IMPORTANT.

CREDO BY TAL

A cartoonist's creed, as voiced by H. M. Talburt:

I believe a cartoon should be simple.

I believe a cartoonist should work on one thought at a time.

I believe a cartoonist should minimize details.

I believe the ideal cartoon would be drawn with one stroke.

I believe a cartoonist should respect his responsibility.

I believe a cartoonist should believe what his picture says.

I believe a cartoonist is a salesman of policy.

I believe a cartoonist in a small way illustrates history in the making.

The Political Cartoon

WORKING UNDER A HANDICAP.

PRESIDENTIAL BEE

60

NEEDED

LEGISLATION

ANOTHER EXAMPLE OF TALBURT'S TECHNICAL
SKILL...HE HAS A GENIUS FOR FIGURE-CHANGING
TO FIT A SITUATION...THE G.O.P. ELEPHANT
AND DEMOCRATIC DONKEY TURNED INTO
"LEGISLATIVE CHICKENS". A PORTION OF THE
ORIGINAL SIZE APPEARS ON THE OPPOSITE PAGE.

The Political Cartoon

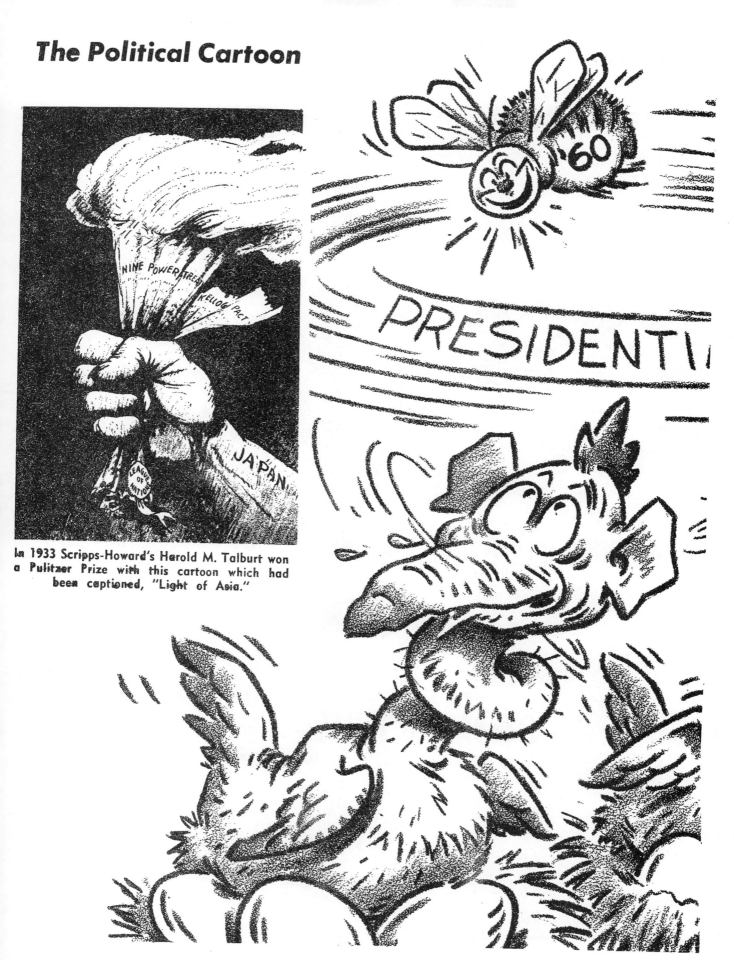

In 1933 Scripps-Howard's Harold M. Talburt won a Pulitzer Prize with this cartoon which had been captioned, "Light of Asia."

General Newspaper Feature

OUT OUR WAY BY J. R. WILLIAMS

I'VE BEEN OUT OF MY APPRENTICESHIP A YEAR NOW, AND I'M MARRIED AND THERE'S A BABY COMIN' AND---.

HA-HA! THAT'S GOOD! TH' OLD BULL O' TH' WOODS KNOWS WHEN A GUY'S TRAILIN' HIM FER A RAISE AN' HE ALWAYS STOPS BY SOME NOISY MACHINE OR MOTOR SO THEY CAN'T BE HEARD--BUT THAT GUY IS CLEVER!

TOO CLEVER-- HE FORGOT THAT IT'LL TAKE THE BULL TWO YEARS TO SEE THE FUNNY SIDE OF THAT!

THE WISE GUY

MOST NEWSPAPER FEATURES ARE HANDLED BY A NEWSPAPER SYNDICATE. THEY HIRE THE ARTIST ON A CONTRACT BASIS AND DISTRIBUTE HIS WORK, IN THE FORM OF MATS, THROUGHOUT THE WORLD...

...IN THIS WAY, NEWSPAPERS CAN HAVE THE SERVICES OF A POPULAR CARTOONIST FOR A FRACTION OF WHAT IT WOULD COST TO DEAL WITH EACH ARTIST INDIVIDUALLY...

...THE CARTOONIST, IN TURN, CAN MAKE MORE MONEY BY SYNDICATION AS HE IS PAID A PERCENTAGE OF WHAT EACH PAPER WILL PAY FOR HIS CARTOON

THIS IS AN ACTUAL SIZE REPRODUCTION (IN PART) OF JIM WILLIAMS' POPULAR "OUT OUR WAY". STUDY THE PEN LINES AGAINST THE REDUCED CARTOON ABOVE.

Reproduced by permission of NEA Service, Inc.

General Newspaper Feature

CAPTAIN EASY Sight-Seeing **BY LESLIE TURNER**

Reproduced by permission of NEA Service, Inc.

LESLIE TURNER IS NOT ONLY A MASTER WITH PEN and INK, BUT HIS HANDLING OF THE CRAFTINT PROCESS IS A WORK OF ART...

THE CRAFTINT PROCESS IS SIMPLY THIS:
THE PAPER IS SPECIALLY TREATED WITH A CHEMICAL THAT WILL PRODUCE EITHER A "SINGLE LINE" OR A "DOUBLE LINE" EFFECT...

A "LIGHT DEVELOPER" IS APPLIED TO THE SURFACE WHERE A SINGLE LINE IS NEEDED

...YOUR BRUSH IS THEN THOROUGHLY CLEANED AND DIPPED INTO THE "DARK DEVELOPER" WHICH WHEN APPLIED WILL PRODUCE A CROSS-HATCHED EFFECT SUCH AS THIS

NOTE: THIS PROCESS IS TO BE DONE AFTER THE PEN AND INK WORK IS COMPLETELY DRY and THOROUGHLY ERASED.

145

General Newspaper Feature

SIDE GLANCES By Galbraith

T.M. Reg. U.S. Pat. Off.
© 1959 by NEA Service, Inc. 7-21

"Paul wants a simple wedding, so I'm only having four
bridesmaids and not a single guest more than
the church will hold!"

GALBRAITH'S PANEL IS NOT
INTENDED TO GET BELLY-LAUGHS,
BUT IT DOES BRING A SMILE
TO ITS READERS AS THE FEATURE
HAS TREMENDOUS HUMAN
INTEREST APPEAL.

THE ORIGINAL DRAWING,
A PORTION OF WHICH
IS SHOWN AT THE
RIGHT, WAS DRAWN
ON THE REVERSE SIDE
OF COQUILLE OR
GLARCO STIPPLE PAPER.
THE ORIGINAL SIZE
WAS 8 x 10 INCHES.

ALTHOUGH HIS PANELS HAVE
THE APPEARANCE OF BEING
SKETCHY and FAST, THEY,
ACTUALLY, ARE WORKED UP
VERY CAREFULLY.. COMPO-
SITION BEING THE IMPORTANT
ITEM.

146

General Newspaper Feature

SHORT RIBS By FRANK O'NEAL

ONE OF THE NEWER COMIC STRIPS THAT HAS CAUGHT ON QUITE WELL IS THE SLIGHTLY, OFF BEAT, ZANY "SHORT RIBS"... IT HAS NO CENTRAL CHARACTER, BUT FRANK O'NEAL, THE CREATOR, BRINGS INTO VIEW ABOUT FIVE DIFFERENT STARS A WEEK... WITH A GOOD BELLY-LAUGH TO MATCH.

...A PORTION OF THE ORIGINAL STRIP IS SHOWN HERE ⟶

SHORT RIBS By FRANK O'NEAL

Reproduced by permission of NEA Service, Inc.

General Newspaper Feature

HERE IS A POPULAR KID PANEL...VERY SIMPLY EXECUTED IN BRUSH and PEN....THE FIGURE IS DONE ENTIRELY WITH BRUSHTHE BACKGROUND and FURNITURE WITH PEN...

SWEETIE PIE By Nadine Seltzer

T.M. Reg. U.S. Pat. Off.
© 1959 by NEA Service, Inc. 7-21

"Weather Bureau? Don't you know it's a sin to tell fibs?"

THIS IS A PORTION OF THE ORIGINAL DRAWING...THE SIZE WAS 8 x 10 INCHES.
NOTICE HOW WELL THE SIMPLE LINES WERE REDUCED.

General Newspaper Feature

TIZZY By Kate Osann

KATE OSANN IS DOING A MARVELOUS JOB OF PORTRAYING THE TEEN-AGED GALS.....THE WHOLE PANEL IS DRAWN WITH A PEN.....SOLIDS ARE FILLED-IN WITH A BRUSH...HER WORK HAS THE SIMPLICITY and FRANKNESS OF A YOUNGSTER.

© 1959 by NEA Service, Inc.
T.M. Reg. U.S. Pat. Off.

7-24

"Sand seems to affect them all the same way!"

THIS PORTION OF THE ORIGINAL CARTOON SHOWS HOW EVENLY HER PEN WORK IS DRAWN...NO OVER-WORKED DETAILS...

ORIGINAL SIZE, 8"x10"

Gloomies

Tea Leaves Failed Her

The Red Dragon Restaurant reluctantly makes public that its seeress and tea leaf reader, Bernice White, who has done so much to illuminate the future and help clients avoid distress, neglected her own future.

I'M GOIN' BACK TO TEA BAGS

She slipped on pavement at Public Square and broke an arm in two places. Tea leaves tell her she'll be back in a few weeks reading tea leaves.

HERE, A LOCAL HUMAN INTEREST ITEM IS SNAPPED UP WITH A COMIC

ONE OF THE MANY JOBS THAT IS HANDLED BY A STAFF ARTIST ON A DAILY NEWSPAPER IS BRIGHTENING UP A STORY OR COLUMN WITH A CARTOON...THESE COMICS ARE KNOWN IN TRADE AS "GLOOMIES"

Even so, the Indians would have won the first game and preserved a much nicer situation in the standings had it not been for atrocious base running. Rocky Colavito and Gary Bell were the culprits, and when Gordon said they ran the bases like little leaguers he wasn't paying the little fellows a compliment.

Colavito was on second base in the first game when Ed FitzGerald hit a hopper to Gil McDougald on which Minnie

Minoso scored the run which put the Indians ahead. There was no question that Minnie was going; there was no question that McDougald would throw to the plate; but when the dust cleared Rocky was still on second. Had he moved up, he would have scored on a long fly by George Strickland.

PART OF A SPORT COLUMN BROKEN UP WITH A COMIC

A Senate subcommittee is conducting hearings in Washington right now on antitrust bills related to professional sports. Pro football already has been defined as a business, and has "welcomed" plans for another league.

I asked Daley if he believes that backers of a third major league would accept a cold-turkey proposition from the majors that would expand each league to 10 teams and guarantee respectable playing personnel. This would take care of those cities which are most interested in big league baseball, such as New York, Minneapolis, Houston and Toronto.

PART OF ANOTHER SPORT COLUMN WITH TWO COLUMN GLOOMIE

POLICE BEAT STORIES ARE FREQUENTLY HUMOROUS... ...A CARBON OF THE STORY IS GIVEN TO THE ARTIST FOR A SKETCH.. ...HIS IMAGINA- TION TAKES OVER WITH THIS RESULT

WHEN IT RAINS—

Partly cloudy, showers and thundershowers, little temperature change tonight. High this afternoon 62. Low tonight 42. Tomorrow c l o u d y, showers, windy and turning cooler in late afternoon. High tomorrow near 50.

FIVE-DAY FORECAST for Ohio, West Virginia, western ··lvania and western New ····res will aver- ··d 3

MOST PAPERS CARRY A FRONT PAGE WEATHER REPORT WITH APPROPRIATE GLOOMIE ATTACHED

This Kiss-Proof Not Thief-Proof— 1152 Sticks Stolen

A lifetime supply of Passion Pink, Misty Red and Hawaiian Sky was the colorful loot taken from a salesman's car early this morning from a parking lot at E. 11th St. and Prospect Ave.

The total loot was 1152 sticks of kiss-proof lipstick along with a briefcase full of orders and papers explaining how to order more just in case the supply runs out.

In Conclusion

IF YOU ARE INTERESTED IN SELLING GAGS OR GAG PANELS ON A FREE-LANCE BASIS, SEND PENCILLED "ROUGHS" ONLY ON 8½"x11" SHEETS OF TYPEWRITER PAPER.

IF YOUR WORK IS ACCEPTED, THE MAGAZINE WILL RETURN YOUR "ROUGH" WITH A REQUEST THAT YOU FINISH IT UP FOR PUBLICATION...

SEND AS MANY "ROUGHS" AS YOU WISH, BUT BE SURE TO INCLUDE YOUR NAME AND ADDRESS ON THE REVERSE SIDE OF <u>EACH</u> GAG! GOOD HUNTING and GOOD LUCK!

" WHY, EVELYN —— HOW CLEVER! "

IN SUBMITTING A COMIC STRIP OR PANEL IDEA, DRAW UP A TWO-WEEKS' SUPPLY COMPLETE IN PEN AND INK and ANOTHER TWO-WEEKS' IN PENCIL ONLY... THIS IS TO SHOW HOW WELL YOU CAN CARRY THROUGH YOUR IDEA FOR YEARS TO COME.

IF YOU PLAN TO MAIL YOUR EFFORTS, BE SURE TO ENCLOSE RETURN POSTAGE, and ADDRESS YOUR PACKAGE TO THE COMIC EDITOR" C/o THE SYNDICATE.

REMEMBER— SYNDICATES ARE ALWAYS ON THE LOOKOUT FOR GOOD IDEAS and YOU NEVER KNOW—YOU MAY HAVE A WORLD-BEATER UP YOUR INKWELL!